ART JOURNAL
art journey

Collage and Storytelling for Honoring Your Creative Process

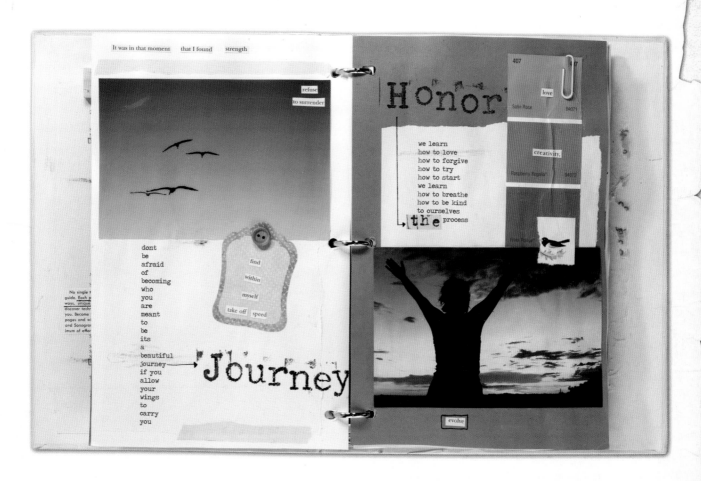

Artist.

Nichole Rae

NORTH LIGHT BOOKS
CINCINNATI, OHIO
CreateMixedMedia.com

Contents

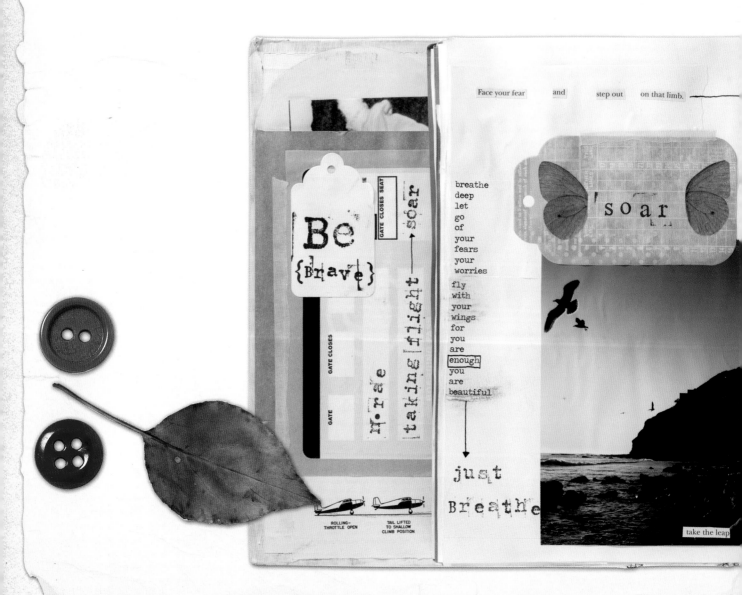

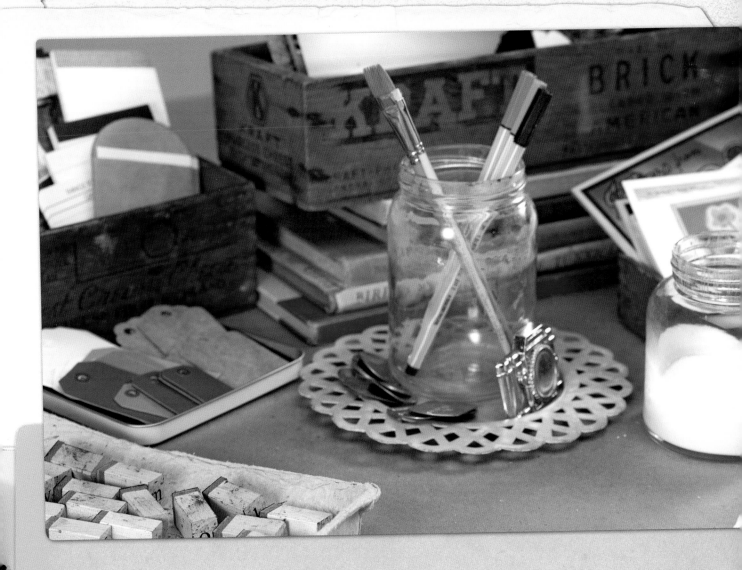

WHAT YOU NEED

3-D letter chips (Scrabble
sticker tiles)

Alphabet rubber stamps

Baskets and Jars

Black felt-tip pen

Buttons

Colored paper clips

Computer

Craft knife

Deck of playing cards

Decorative papers

Envelopes

Ephemera (stickers, receipts,
fortune cookie fortunes, etc.)

Fine-point Sharpie pen

Gesso

Glue stick

Hardcover used book

Image rubber stamps

Ink pad

Ink pens, fine point

Label maker

Markers

Masking tape

Oil pastels

Paintbrushes

Paint samples

Photographs

Postcards

Printer

Printer paper

Sanding block

Scissors

Small wire-bound journal

Tacky glue

Used books (inspirational or
themed)

Washi tape

White glue

Word stickers

Welcome to Your Creative Journey

I sit
in my
studio
music playing
a cup of coffee
my favorite "artist" mug
beginning
to write
this introduction
I carry
the
word
journey
I carry
book
pages
I
carry
boxes
of
papers
buttons
photographs
I carry
the
excitement
of
connecting
with you
along
this
journey
page
by
page
let's
create
together

When beginning on a journey there are moments of excitement and then there are the moments when you start to write your to-do list, filling it with what you need to do before you go, what you need to pack and all the things you want to do on your trip. The beauty of a "creative journey" is that the preparation and the adventure are all part of the journey. Through art journaling, your to-do list becomes the documentation of your path, and what you need to do becomes the story you are creating. What you want to do on your trip unfolds into your ideas and vision. Along this adventure we will explore together how you can document your journey using art journaling.

It is important to know that I am learning just like you are: learning how to navigate my path, learning how to create what I need and learning how to trust the process. Over the last ten years I have been exploring the process of art journaling and mixed-media collage. As I write this book, I have discovered that I am still beginning my journey and that my process is unfolding as I go. I have found that a beginning holds possibility and the excitement of the journey, as well as the beautiful discovery of who we are, what we need and what we want to create along our path.

The pages in this book can be used as a guide along your journey. They are filled with the favorite "bits" I have collected along the way that have helped me explore who I am, the path I have been on and where I want to go. It is filled with inspirational quotes, words and images to spark the excitement we all love to feel before an adventure. It provides direction about where to start, what you will need with you to get started and creative project ideas. I share styles of art journaling, mixed-media collage techniques, favorite supplies and how to set up a work space. As you go through this book you will learn how you can create your own journal using photos, ephemera and journal entries to document your journey. You will also find other ways to be creative through mini projects such as affirmation books, mini inspirational cards and an altered book.

My truest and deepest intention for this book is to connect with you on your path. These pages are written to guide you, inspire you, offer ideas, provide direction and prepare you as you begin this journey. I am excited for you as I write this. I honor your bravery, your creative spirit, your bold leap as you embark on a beautiful path of self-discovery filled with learning, discovering and unfolding. I am honored that we can take this journey together. Along the way, know that I am with you.

–Artist Nichole Rae
{from my studio to yours,
coffee mug to coffee mug, cheers !}

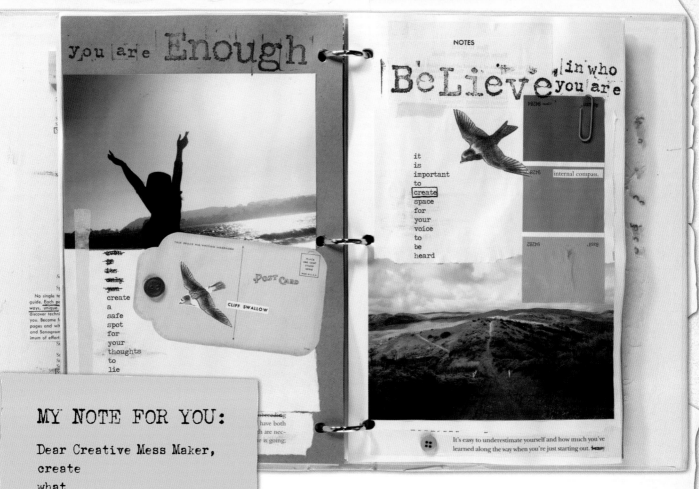

MY NOTE FOR YOU:

Dear Creative Mess Maker,
create
what
you
most
need
to
find
visualize
your
journey
document
your
ideas
your
dreams
your
vision
share
your
story
you
are
enough

Live Your Life.
Create Your Journey.

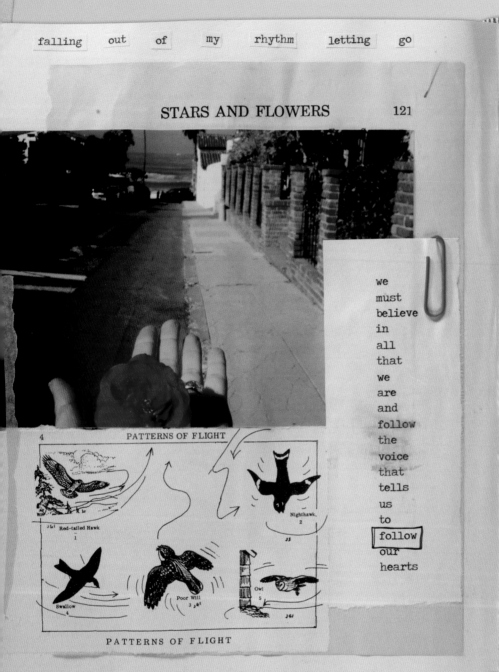

STARS AND FLOWERS 121

we
must
believe
in
all
that
we
are
and
follow
the
voice
that
tells
us
to
follow
our
hearts

PATTERNS OF FLIGHT

it is time....

it
is
what
we
learn
along
the
way
that
leads
us
to
where
we
want
to
go

SNAPDRAGON
E817-2

11.2.2012

{1} The Journaling Process

sten
o your
r voice}

LING BY COMPASS ALONE
oses for which you can use the compass alone—
help of a map—are these:

tions—"bearings"—from a location.
direction—a "bearing"—from a location.
your original location.

g a new path

The art of journaling can be a new and exciting process. Over the course of my creative journey I found it difficult to write my thoughts and feelings on paper. I allowed fear to hold me back, finding excuses to keep me from actually setting those thoughts free. "I don't like my handwriting." "I need the perfect journal that feels right." "If I write in ink I won't be able to erase." During this time the voice inside me kept whispering, "Set your thoughts free. Write them down on paper to grow and evolve. They need to be heard."

One morning while having coffee I was working in a document on my computer for a project and I realized how much I like typing, choosing fonts and having the ability to use the delete button. I found freedom in the options a computer document offers. I felt the anxiety begin to fade away when I started to type my thoughts and feelings. I was able to type, delete and type again, as well as choose my fonts and layout. I could keep this document in a folder on my desktop and come back to it when I felt like it. I had a place to write and collect my thoughts, finally journaling the voice that needed to be set free.

In this chapter I will share with you how I journal, going deeper into the writing process. I will help answer the questions that you may have and provide helpful tips that can make this process fun. We will explore the "how" and the "what" of the journaling process. These questions will provide an artistic direction for you to travel in and give you the confidence you need to take this journey. You will learn how to create compelling text, the importance of taking your time and my favorite list-style journal format. Advice about how often to journal, the best way to keep your text organized, as well as inspiring prompts that can guide you in your writing process can be found in this chapter.

Journaling allows you to discover your own voice. We are able to grow and evolve as we set our thoughts free, embracing and honoring our journey. Together we will journal the words we carry, our days and what we most need to find along the way.

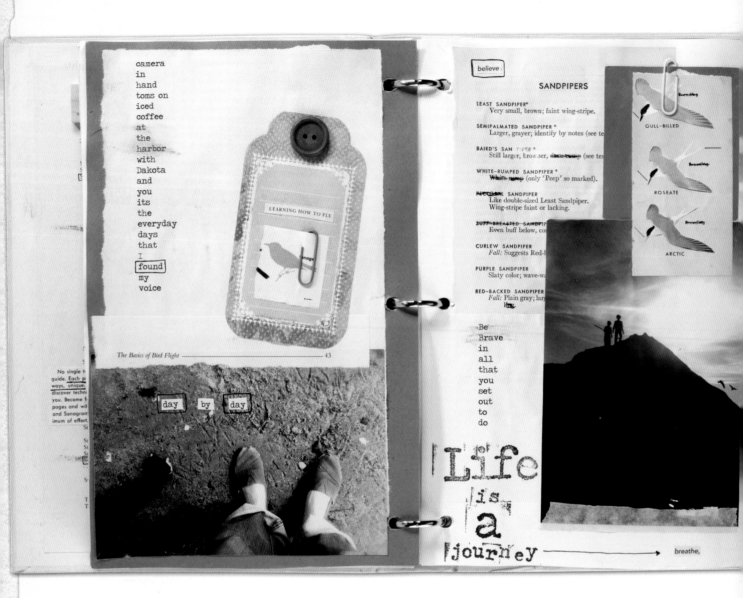

camera
in
hand
toms on
iced
coffee
at
the
harbor
with
Dakota
and
you
its
the
everyday
days
that
I
found
my
voice

LEARNING HOW TO FLY

The Basics of Bird Flight ——————— 43

day by day

believe

SANDPIPERS

LEAST SANDPIPER*
Very small, brown; faint wing-stripe.

SEMIPALMATED SANDPIPER*
Larger, grayer; identify by notes (see te

BAIRD'S SAN IPER*
Still larger, browner, (see tex

WHITE-RUMPED SANDPIPER*
White (only 'Peep' so marked).

PECTORAL SANDPIPER
Like double-sized Least Sandpiper.
Wing-stripe faint or lacking.

BUFF-BREASTED SANDPIP
Even buff below, co

CURLEW SANDPIPER
Fall: Suggests Red-b

PURPLE SANDPIPER
Slaty color; wave-w

RED-BACKED SANDPIPER
Fall: Plain gray; lar

GULL-BILLED

ROSEATE

ARCTIC

Be
Brave
in
all
that
you
set
out
to
do

Life
is
a
journey ——————→ breathe,

 Visit **CreateMixedMedia.com/art-journal-art-journey** for bonus content.

Beginning to Journal

When starting the journaling process, it is normal to feel overwhelmed or even unsure about where to begin. We all need a bit of guidance about exactly what to focus on when trying something for the first time. The freedom in art journaling allows you to embark on a journey, to explore your inner voice, your vision, fears and feelings. Art journaling creates opportunities to explore who you are, where you have been, where you want to go and who you are becoming. These themes and ideas can be used as inspiration when journaling. I understand the fear of starting; even after completing several projects I still have that initial uneasiness of documenting my thoughts on paper. It is important to write from your heart and honor the thoughts and feelings you carry along your path. Remember, we are in this process together.

One of my favorite times to journal is in the morning before I begin my day. During this time I can relax and enjoy my favorite cup of coffee. During this time, I allow myself the freedom to journal about what is on my mind, things I need to do, ideas, thoughts about events from the day before and emotions from my past. It is about documenting your journey as you go, just the way you are. I have learned over time that it is helpful to journal your thoughts exactly where they are at the present time.

When beginning to journal, turn on your favorite music. I find that music inspires my journaling process. Listening to the rhythm helps my mind relax and I am able to settle into my work space, and allow my thoughts and creativity to flow. Choose music based upon how you are feeling at that specific time. Listening to the lyrics and feeling the rhythm can help set the mood for you to explore your thoughts.

Once you have set the mood with your music, take a few moments to look at your surroundings. Notice what objects are around you, the light coming in your space. Beauty lies in simple happenings: leaves falling from the trees, birds flying outside your window. You may be traveling or sitting in your favorite coffee shop. Taking a few moments to bring your attention to your space can help bring a sense of comfort and calmness, allowing a connection to be made with your space. These visual references, as well as the rhythm from the music, can create a foundation for your writing to begin.

Journaling can strengthen your heart and show you your bravery and your voice.

TIP

A list of my favorite music can be found on the Resources page at the end of this book.

Trust the process.

THE EASE OF LIST-STYLE JOURNALING

Journaling your thoughts and feelings can often be an exciting experience. When exploring art journaling, there are many ways you can record your thoughts. One of my favorite styles is to use a list-style format. Many people are very good at making lists. I have a stack of to-do lists in my studio as I write this. I found that journaling in a list format helps me put my thoughts down on paper without feeling the pressure of writing a large amount of text.

When using a list-style format, I record my thoughts one line, and sometimes one word at a time, thereby creating a vertical journal in my document. This style takes away the feeling of writing in a book format and allows me the freedom to explore the art of poetry. Having one word on a line is what makes this style evolve all on its own, creating rhythm within the words. My writing style is very similar to poetry. In poetry, the writer will use different techniques such as rhythm, repetition, metaphors and similes. You can apply these techniques to writing in a list-style format. This method allows for flexibility and can be fun at the same time.

TIP

When creating list-style journals, allow your thoughts to flow freely without worrying about proper punctuation and capitalization.

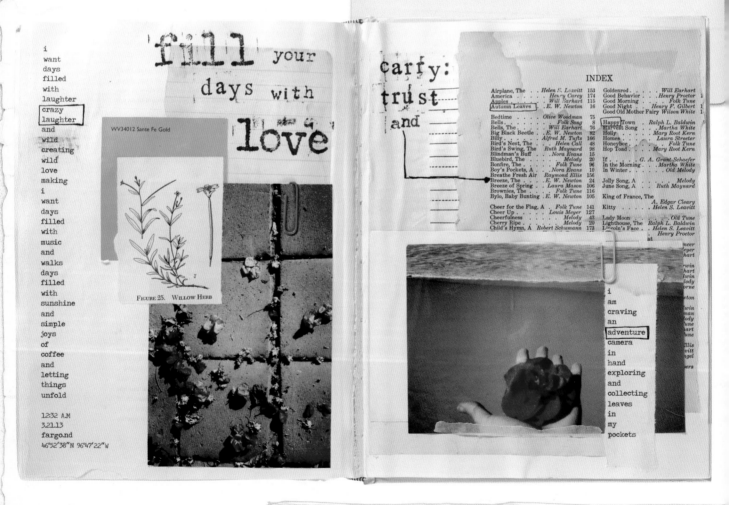

Create your life one list at a time.

Visit **CreateMixedMedia.com/art-journal-art-journey** for bonus content.

PROMPT IDEAS TO LIST YOUR JOURNEY

With journaling I often take an abstract approach to my text, exploring my feelings in words that may not be completely direct. I often explore my feelings through comparisons such as flight, the ocean, birds, places I have visited, living in a new place, to name a few. I have found, over time, that a common theme underlies the words of my journaling.

For some of my projects I use prompts to create a focus for the book. One of my favorites is "I Carry," or "The Words I Carry." This prompt inspires me to journal my thoughts and helps calm the "blank canvas feeling" that many of us experience. This writing prompt works well for me when I am unsure what to journal about or when I have a lot on my mind. It allows me to start making a list of anything I am thinking of or want to explore. It can be what I need to do that day, ideas, my goals, feelings about events from my week, etc.

Depending on the theme for the book, prompts can work well to get you started on the journaling process. A theme provides a sense of direction for beginning your exploration of the art journaling process. Having a theme can be a helpful guide when you are starting something new. It can inspire the creative process, what supplies to look for and where to start. A theme is like having a plane ticket: You know where you are going once you have the ticket in hand.

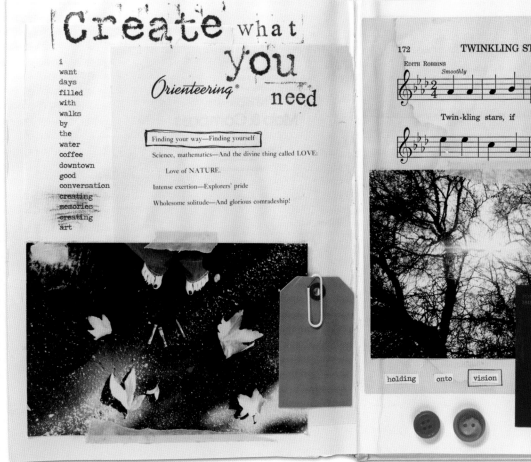

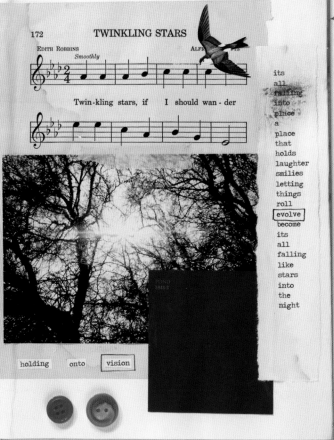

KINDS OF LISTS

When using the list-style format of journaling, I explore different topics and writing prompts. I enjoy using the writing prompt "I Carry"; this list holds all the thoughts I have going on in my mind. These creative lists inspire me to explore and process what I am holding onto at that time. On these pages you'll find examples of lists inspired by the following prompts:

- I carry
- I am
- I want
- I need
- Journal based on your surroundings
- Word association

THEMES

Personal journey: document day-to-day moments

Travels: Trips you have taken or would like to take

Hobbies—Nature, adventure, cooking or other things you enjoy

My favorites: the ocean, flight, birds, travel

BE INSPIRED.

Need a theme or direction about where to begin? At the back of this book is a list of words that I find inspirational when writing—maybe you will too.

I CARRY

I carry. . .
book edits to do
plans for my weekend
wanting to create more
needing to find ways to manage my time
wanting to go thrift store shopping
I carry
wondering what i will make for dinner
thoughts of my dog Dakota
a beautiful conversation with my friend
Randi
the overwhelming feeling of chasing my
dreams
trying to believe in my journey
trusting that things will unfold
needing to organize my office and studio
space
my dad coming next week
my sisters wedding in 11 days

I AM

I am
chasing my dreams
trying to manage my time
trusting that i can live my life as a full
time artist
I am
a bit tired, need more sleep
I want
to take a trip
to create in my studio all day with no
distractions
i want
to go dancing in my cowboy boots
I need
to snuggle on the sofa with lots of blankets
and watch You've Got Mail
I need to
slow down, listen to my body
I need
to get more rest

{soar} above
TABLE OF CONTENTS

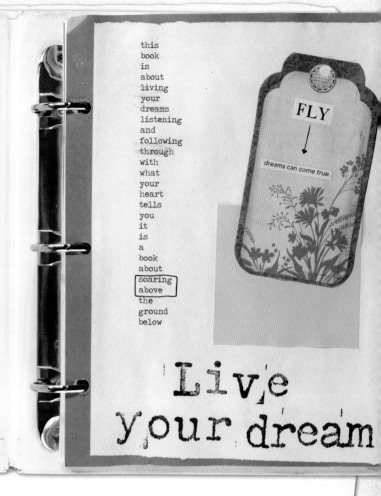

this book is about living your dreams listening and following through with what your heart tells you it is a book about soaring above the ground below

FLY ↓
dreams can come true.

Live your dream

TASK:

Create a List-Style Journal Based on Your Surroundings

1. Open a blank document on your computer.
2. Begin to look at your surroundings and start writing what you see, hear, feel, thoughts in your mind, etc.

> Coffee shop
> music
> watching people
> passing by
> 6:25 pm
> summer night
> sitting
> writing
> iced coffee
> almost
> gone
> the song
> flying by your window
> by
> Jason Myles Goss is playing
> i am
> feeling
> calm
> trying
> to stay focused
> wanting to meet
> my friend ashley
> at her shop

TASK:

Explore Word Association

1. Open a blank document on your computer.
2. Write one to three words that come to your mind on one line.
3. Then add another word/s below that line that you associate with the first word/s you wrote.
4. Continue to journal, line by line.

> summer
> long days
> create plans
> travel
> schedule trip
> go to California
> miss the ocean
> need balance
> take a yoga class
> listen to my body
> rest more

OTHER WAYS OR STYLES OF JOURNALING

My signature style of journaling is in a document on the computer, but there are a variety of ways you can document your thoughts.

Handwritten Journaling

When I am not in front of my computer or when I am not inspired to type, I will do handwritten journaling in a notebook or journal. I follow the same style of writing, in a long vertical list-style format.

Here you can explore different styles of handwriting you may have: cursive, capitals or all lowercase. You can also use different color pens, pencils, lined or solid paper, different colored paper, individual sheets or even index cards that you can use in your book project.

Found Poetry Journaling

Another option for journaling is to use found words from books. This style is often referred to as found poetry. To do this style of journaling you need a pair of scissors, a glue stick and some old books you can cut words out of.

At this point you can glance over the old book pages and see what words call to you. Cut them out and start a pile. From there you can arrange these words in list form and glue them on paper.

The beauty of this style of journaling is that you are able to explore your feelings and thoughts with words already written. This style is about playing with different words you may not use on a daily basis. You can also have fun with the layout of these words by gluing them close together or leaving spaces in between them. Other options for embellishing these found poetry words will be demonstrated in chapter three.

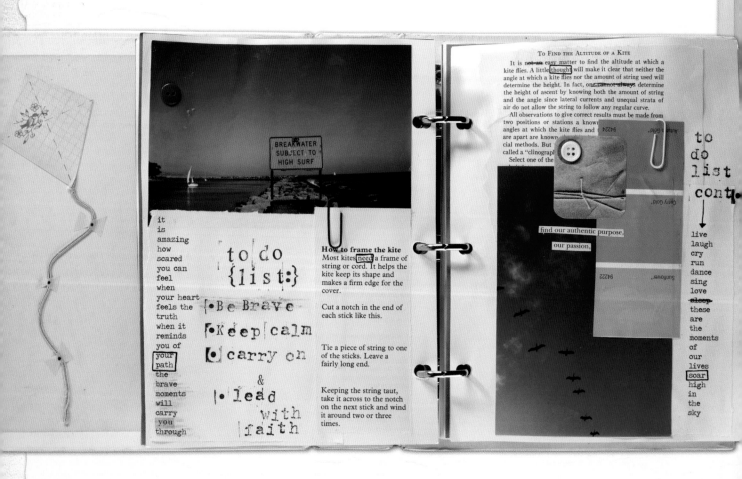

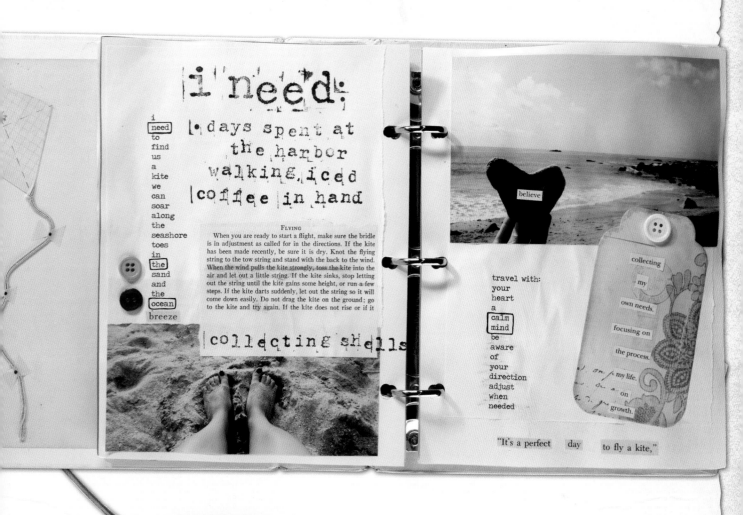

Document your journey.

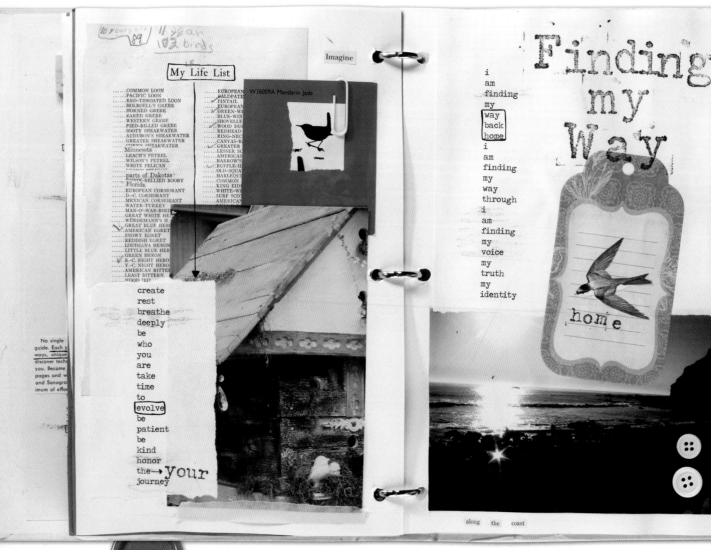

My Life List

Imagine

i
am
finding
my
way
back
home
i
am
finding
my
way
through
i
am
finding
my
voice
my
truth
my
identity

Finding my Way

home

create
rest
breathe
deeply
be
who
you
are
take
time
to
evolve
be
patient
be
kind
honor
the→ your
journey

along the coast

Let your ideas soar.

Visit **CreateMixedMedia.com/art-journal-art-journey** for bonus content.

ORGANIZING MORE THAN ONE BOOK OR JOURNAL AT A TIME INTO FOLDERS

Once you begin the journaling or creative process, you will find that inspiration comes to you in all kinds of ways. It is normal for your mind to start racing with ideas or themes you want to explore. It's beautiful how once we open the door to creativity it fills our hearts with purpose and excitement.

I often have different projects in mind at one time and will have separate documents created for each. On my desktop I will have a folder titled "Projects in Progress" where I can organize my journal documents. This is a simple way to work on multiple projects at once.

I like to title my journal documents by theme or the title of the project, if I have decided on it, and the date I started the journal. For example, for my next project theme, I am exploring the path I am on. Sometimes, though not always, I will have the title for the project already in mind. For this project I have titled the document "Creating My Path March 2013." So when I see this document, I know what project it is, the theme and when I started it. I have another journal document started that I titled "By the Sea, October 2012." Here I am collecting journaling about an ocean theme.

The goal is to title the document something you can remember. If for some reason it does not save on your desktop you can find it amongst your other files, and as you begin to journal more and work on multiple projects you will be able to keep them organized to find them when you need to.

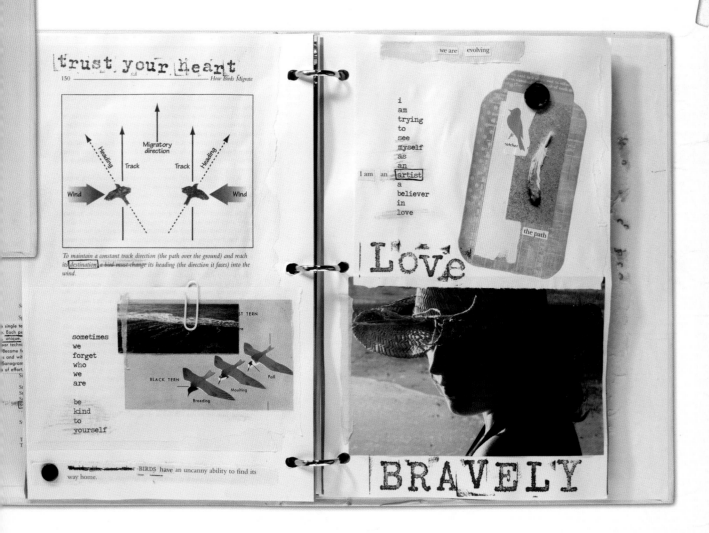

BE INSPIRED.

- Listen to music.
- Set the environment with coffee or tea, good lighting, inspirational books, etc.
- Put on your favorite movie.
- Get in comfy clothes.
- Light candles.
- Get a cozy blanket or sweater.

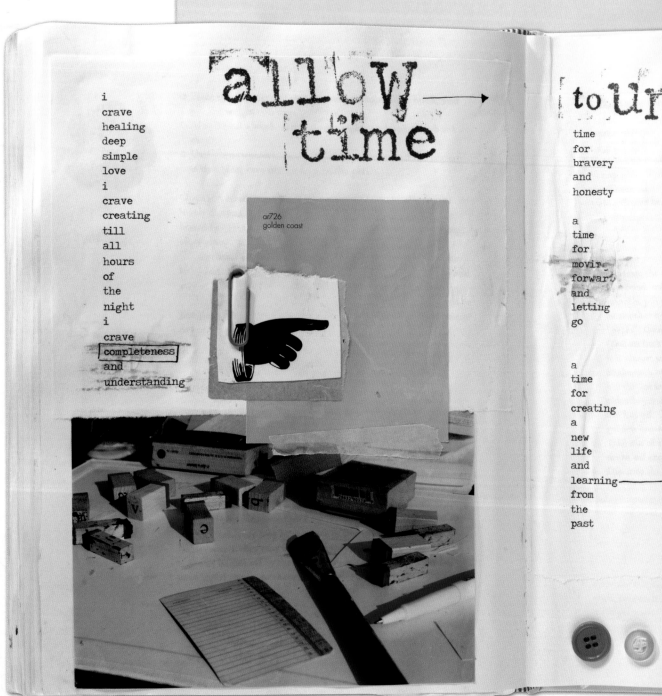

allow → time

i
crave
healing
deep
simple
love
i
crave
creating
till
all
hours
of
the
night
i
crave
completeness
and
understanding

ar726
golden coast

to un

time
for
bravery
and
honesty

a
time
for
moving
forward
and
letting
go

a
time
for
creating
a
new
life
and
learning
from
the
past

HOW OFTEN TO JOURNAL

I have created a time in the morning for doing most of my journaling. I brew a cup of my favorite coffee, put on some music and sit in a comfy chair in my studio. Here I open my journal document and let the music inspire me. I find this to be a beautiful way to start the day. It's a set time for myself to relax and focus on my vision for the day.

Throughout the day I am often inspired to journal. If I am away from my computer I will use my smartphone's notepad feature to create a list-style journal. I have ongoing journals in my phone and, when the journal is done, I'll will e-mail that text to myself to then add to the main document on my computer.

There is no rush when journaling, though it is important to try to journal a bit every day. Journaling is like any task you do—it takes time to develop a habit and for it to feel natural. Once you begin a journaling habit, you will find yourself craving the time to sit and explore your thoughts. It is up to you how often you want to journal; if you are excited to start a project you may compile more journaling in a short period of time.

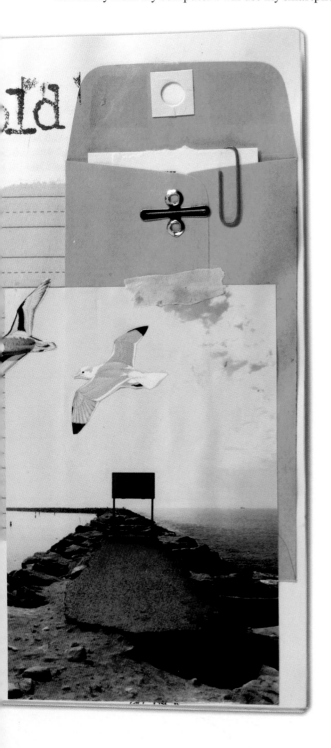

CREATING TIME TO JOURNAL

When beginning to journal, I have found that setting a small amount of time aside to focus on this task is helpful. When starting something new, it takes time to create a rhythm. A transition period occurs when you are starting something new. After committing to trying something new for a few weeks, the "something new" begins to feel natural and a part of your day-to-day life. I started waking up twenty to thirty minutes earlier than normal to allow time to journal. It was hard in the beginning to get up earlier than usual, though eventually I found it to be beneficial to take time for myself. I also take time in the evening before going to bed to journal.

You do not need to set aside a lot of time to journal; even ten minutes to put your thoughts down on paper will be enough. We all have random downtime in our days: waiting for an appointment, for a train or for a meeting, traveling, etc. These environments can often be inspiring if you are open to them. Music may be playing or you may be by yourself for a moment in your busy day when you can explore the thoughts you carry.

embracing the journey

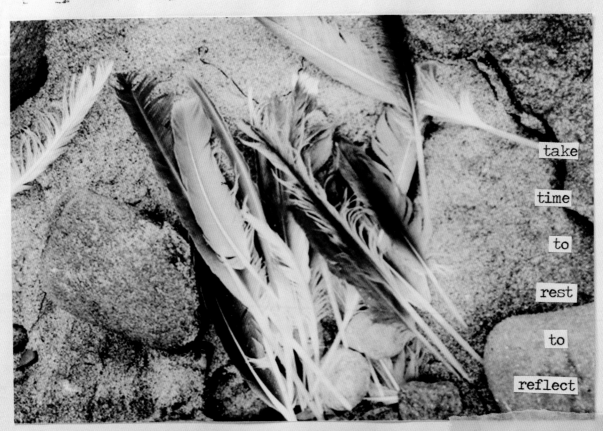

take

time

to

rest

to

reflect

Map and Compass in Your Everyday Life

Fundamentally, we all make use of maps and compass directions in our everyday lives—consciously or unconsciously.

When you sit down to plan a trip, whether by automobile, rail, ship, air, or on foot, you get out maps or charts and try to figure out the shortest way, the best way, or the way that will take you past the greatest number of interesting places. Then, on the trip, you consult your maps repeatedly to check where you are and where you are going.

When someone asks directions or when someone gives them to you, your brain automatically attempts to draw an imaginary map of the location. In your mind you see roads as lines, rivers as bands, buildings as small squares—exactly the way they are represented on a map.

Map and Compass for the Outdoorsman

The experienced outdoorsman has no fear or uncertainty about traveling through strange territory—map and compass will get him there and safely back again.

THE IMPORTANCE OF TAKING YOUR TIME

The art of journaling is a beautiful process. There is no right or wrong way to write, as well as no timeline unless you set them for yourself. This process allows you the personal freedom to explore your thoughts and feelings day by day.

When working on your journaling, it is important to allow yourself time. I set a three- to six-month time frame when working on a body of text. I find that this time frame allows me the space to explore my thoughts and honor the process without feeling rushed. During this time you grow, you experience life's moments and they then shape the journey you are on, in turn shaping your journaling. Choose a time frame that works well for you.

When journaling, I do not go back to revise the text. Writing in the present time is important to seeing your journey unfold in words. Once you decide to print the text, you can choose what you want to use as well.

I often start multiple journal documents on my computer to set the writing process in motion. I save them to my desktop and am able to work on them little by little. Over time I will have a collection to use for my projects. Once I begin these journaling documents, my heart feels content to know they are created and will evolve with time. The simple joy of having them started provides comfort, knowing they are there to visit at any time.

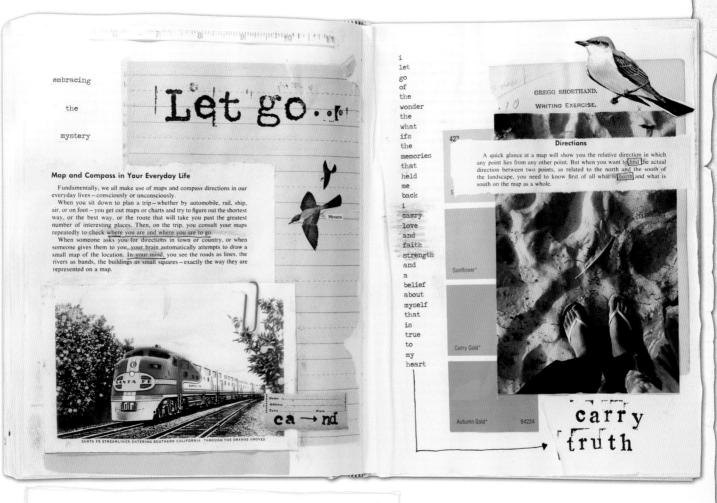

Day by day.

Take small steps.

Preparing to Print Your Journals

"The joy is in the journey." This is one of my favorite quotes for the art journaling process that we are on. You are the leader of this journey.

Getting ready to print your journal is exciting, though it can also bring uneasiness knowing that your text will be printed and that you are moving forward. At this time it is important to be proud of yourself and your creative spirit.

When working on the main book project, a journal page is adhered to each page. This gives you an idea of how many pages of text you will need. You can also choose not to fill each page with a journal pages. If you do not have enough journal material after you print you can skip journal text and add other elements such as found poetry or rubber letter stamps.

As the artist you are able to choose when you write, how long you write and when you are ready to print. I print once I feel I am done journaling and have come to

an ending point for the text. If you would like to have the hard copy journals with you, you can print them each day or in sections. I choose to print all my text at the end to help keep things organized and keep everything together.

When journaling I focus on the writing and not on how many pages I have journaled, though if you have chosen the book you will be working in, you will know how many pages you will need. I almost always have more journal pages than I need.

In the next sections you can select a font, one of my favorite things to do, along with choosing the text size and layout. These steps are filled with flexibility, allowing you to try something new while having the opportunity to edit, delete and change things until you find what fits your needs for your project. We will also explore a variety of helpful editing tips that will provide the guidance you need to successfully print your text and move forward along this creative journey.

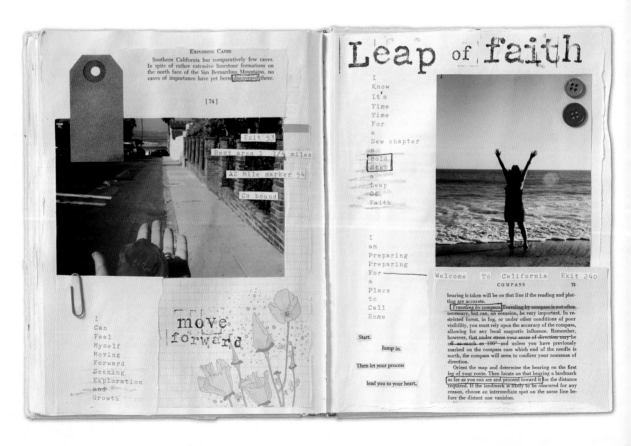

Visit **CreateMixedMedia.com/art-journal-art-journey** for bonus content.

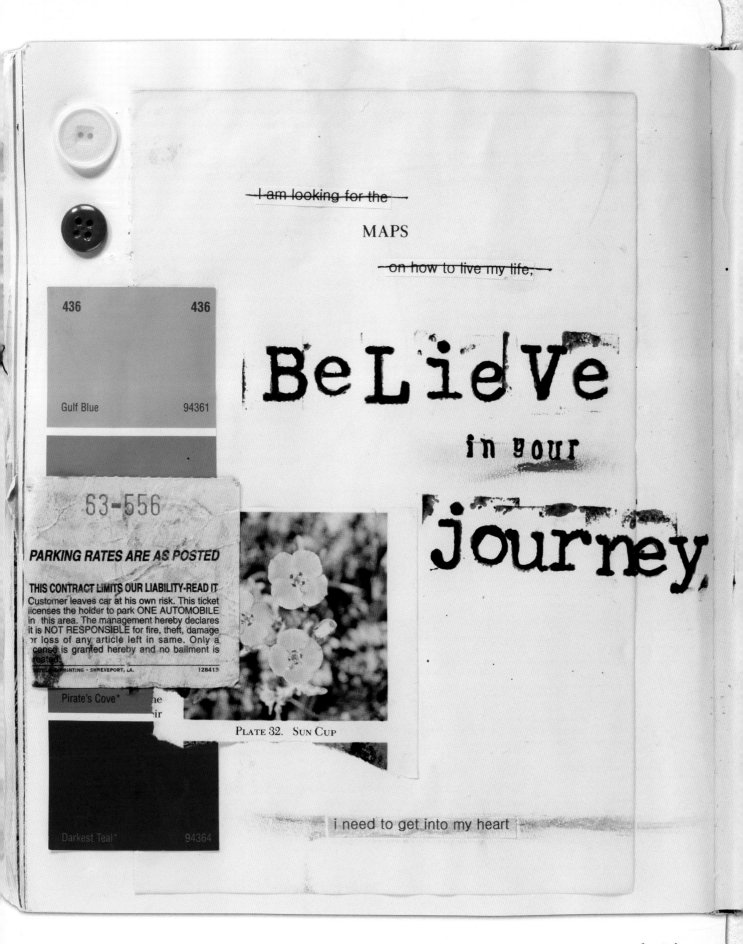

I am looking for the

MAPS

on how to live my life,

BeLieVe
in your
Journey.

63-556

PARKING RATES ARE AS POSTED

THIS CONTRACT LIMITS OUR LIABILITY-READ IT
Customer leaves car at his own risk. This ticket
licenses the holder to park ONE AUTOMOBILE
in this area. The management hereby declares
it is NOT RESPONSIBLE for fire, theft, damage
or loss of any article left in same. Only a
cense is granted hereby and no bailment is
reated.
HTLE... PRINTING - SHREVEPORT, LA. 128413

436 436

Gulf Blue 94361

Pirate's Cove*

Darkest Teal* 94364

PLATE 32. SUN CUP

i need to get into my heart

Selecting a Font and Size

One of my favorite moments along this journey is having the printed journal text in my hands and off the computer. I am learning to love technology as I continue to grow in my journaling process. I am definitely a crafty girl at heart and have a love for shoeboxes of paper and photographs.

Once you have completed your journaling it is time to add your style by choosing your font and text. You are able to emphasize certain words with a bold style or larger size. Again, keep in mind the freedom this step provides. You are the artist; have fun exploring different fonts and sizes.

When journaling, I usually work in the preset font and document size when I initially begin. Choosing to do this helps simplify the setup process and shifts my focus to the journaling, allowing my thoughts to flow freely on paper. My favorite font is Typewriter in a 10-point size, though the size of the book you have chosen will determine if you need to use a smaller text size to be able to fit a list-style journal on one page. Sometimes the list will be two pages regardless of a smaller text size; if this happens, find a point to separate the list and continue onto the next page. For my larger book projects I usually use one font and size for all the text, though you can choose multiple fonts and sizes if you like.

MATERIALS LIST

computer

journal files

printer

multipurpose computer paper

 Highlight your text and select "Font" from the menu bar.

 Test out different fonts to see which one you like.

i am
here
to
create
my
days
i
carry
the
vision
of
truly
living
leading
with
faith
trusting
my
inner
voice
it
is
the
simple
beauty
of
following
through
unfolding
and
becoming

3. Once you have found a font you like, try the font in different sizes.

4 Print a sample page and compare it to the size of your book before printing off all of your journal pages. It is easier and less wasteful to reprint one page than all of them.

TIP

Depending on the size of the book you are working in, you can rip or cut down the printed journal page to the size you would like for that page.

FOR THE LOVE OF FONTS

Great websites exist where you can download fonts to add to your collection. Some sites are free, some ask for donations and others charge a small fee. With these sites you can build your collection of fun, modern, cursive, typewriter and many more font styles. Check out the Resources section for a list of some of my favorite font websites.

ORGANIZING THE PAGE LAYOUT

Before I print, I also organize my journaling to have one list journal on each page of the document. This prevents your text from getting cut off while printing. Sometimes my list journals are longer than one page and I will find a place where I can separate the text and continue it onto the second page.

In a document you are also able to align your text to the right, left or center. When I work in a book that's smaller than 8" × 10" (20cm × 25cm), I keep my text aligned to the left so I only end up needing to tear the right side and bottom.

When I work in a larger book (see *Mini Project: Altered Book* in Chapter 3) I choose a center alignment. I also use the page setup option to size down the document to 8" × 10" (20cm × 25cm). By doing this, the text is more likely to stay centered after I tear off a bit of the excess white during the collage process. Visually, this fits the style I like to create, though you can experiment to find a style you like.

Live with intention.

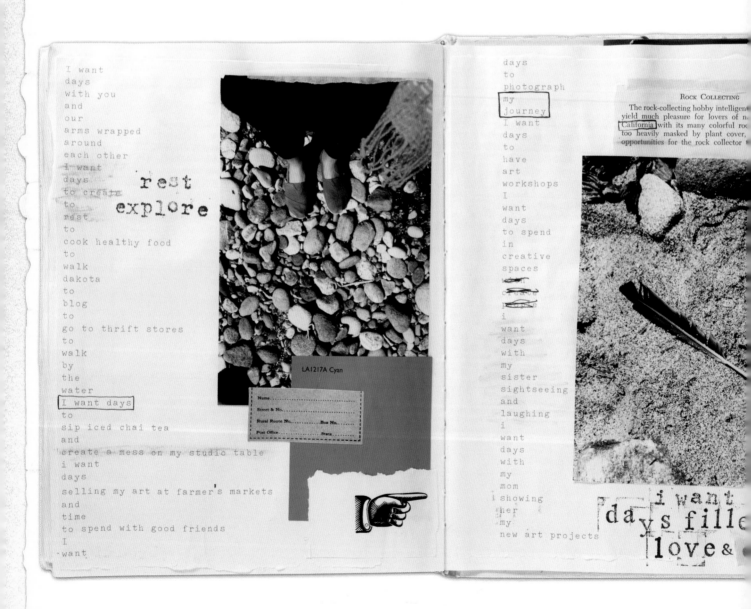

THE PRINTING PROCESS

When printing my journal pages, I use a standard home ink-jet printer. I print on multipurpose computer paper. This is thicker than copier paper and usually comes in a bright white. This paper is also easy to tear when sizing it down to fit your page.

I always print on white paper, though you can print on colored paper. (Brown kraft paper–style cardstock creates an organic feel.) You can also use textured cardstock or colored paper, if you like. Please be aware that the heavier the paper, the thicker the book becomes along the binding. I love how the book expands to the point of not being able to close it completely, filling it with my life.

Carry your truth.

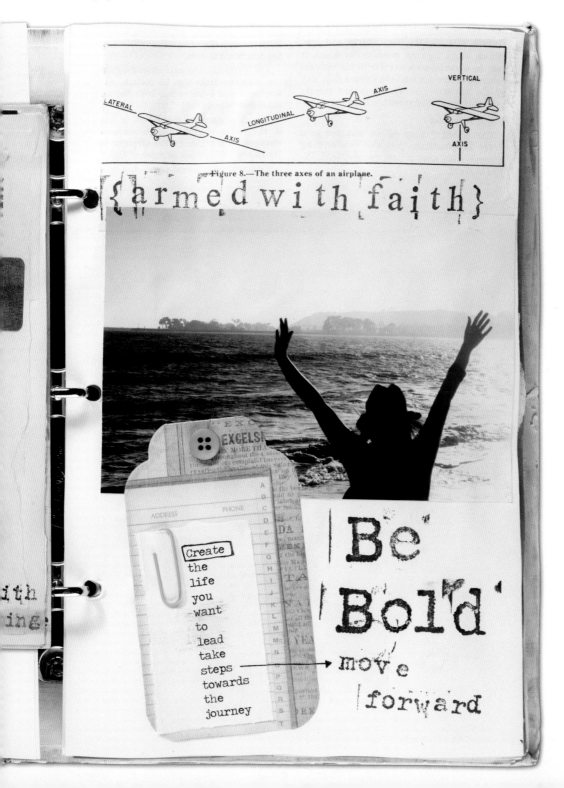

Figure 8.—The three axes of an airplane.

{armed with faith}

Create
the
life
you
want
to
lead
take
steps
towards
the
journey

Be Bold
move forward

Organizing the Printed Lists Into Categories

The process is unfolding as we move forward on this creative journey. One of my favorite parts of this process is holding my printed text in my hands. To know my words have been printed and my voice is evolving with each list is exciting.

It is normal for this step to bring up some feelings of fear: fear of having your thoughts on paper and not stored in a folder on your computer anymore, fear of rereading what you have written, fear of moving forward. It is important to remember that fear is part of the process and we all have these feelings. I know that when I first started I would often judge myself and wonder why I would write certain things. I would go through my stack of journal lists and not want to use any of it because I carried fear. I worried about what people may think and how I was exposing the deepest parts of my mind and heart on paper. This voice inside us is fear, and we need to remind ourselves that fear holds us back. When we lead with love, we begin to create freely.

Art journaling is about evolving and becoming, learning and discovering who you are. During this time we must embrace our voice and our bravery and know that these steps, printing our journaling, will set our voices free to soar. The beauty of this step is that you are able to choose what journal lists you want to use and what order you would like to arrange them in your book.

In this section we will explore how you can create a story from your printed lists by categorizing them and looking for common themes that may be uncovered as you begin to read through them. When you journal you are embarking on a journey, and during this process you can uncover your path and discover your story.

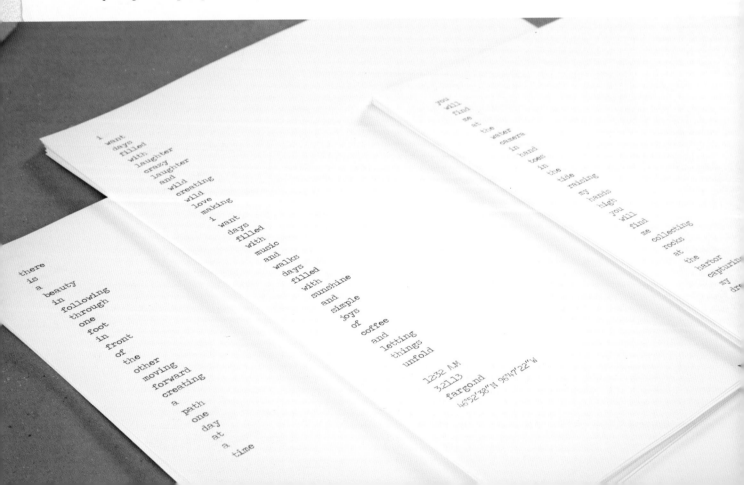

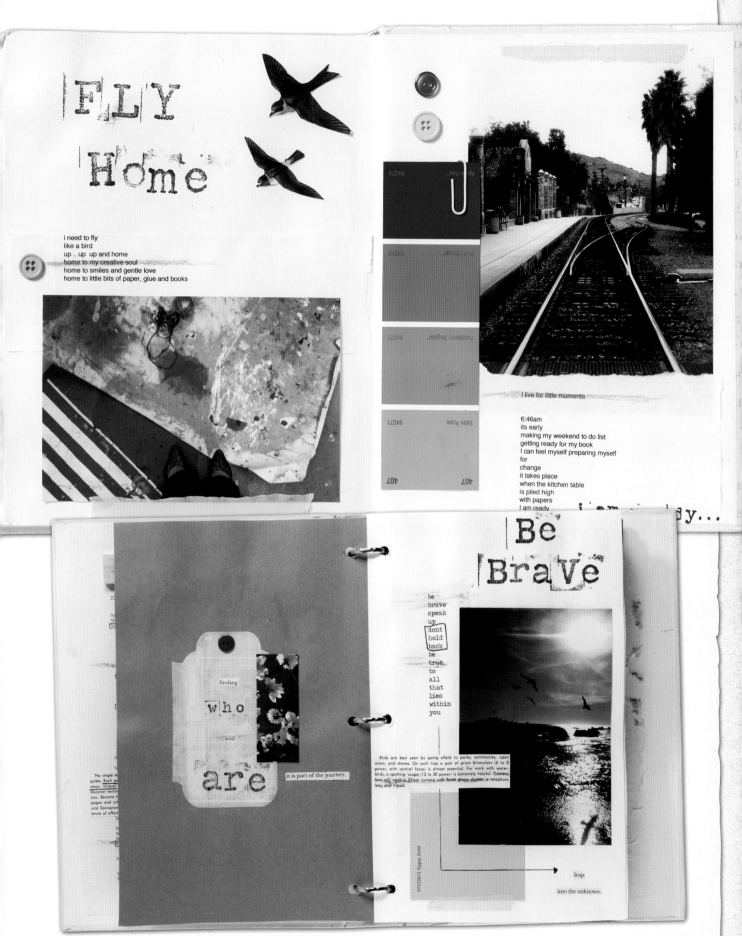

FLY
Home

i need to fly
like a bird
up .. up up and home
home to my creative soul
home to smiles and gentle love
home to little bits of paper, glue and books

I live for little moments

6:46am
its early
making my weekend to do list
getting ready for my book
I can feel myself preparing myself
for
change
it takes place
when the kitchen table
is piled high
with papers
I am ready

finding

who

you

are

it is part of the journey.

Be
BraVe

be
brave
speak
up
dont
hold
back
be
true
to
all
that
lies
within
you

Birds are best seen by going afield to parks, sanctuaries, open
areas, and shores. On such trips a pair of prism binoculars (6 to 8
power, with central focus) is almost essential. For work with water-
birds, a spotting 'scope (12 to 30 power) is extremely helpful. Camera
fans will want a 35mm camera with focal plane shutter, a telephoto
lens, and tripod.

leap

into the unknown.

NOT ALWAYS CHRONOLOGICAL

Once your journal lists are printed, it is time to organize them for your project. It is important to keep in mind that this step comes with lots of freedom, allowing you to create your story with the journal lists you have written. My process has evolved over time as I write, print and create books. You will discover your process, though I will provide some direction on where you can begin this step.

After I have printed my journals I take time to read it and often uncover common themes in the text. These themes often shape the order the text will go in. I find that this step can be best described in a visual way. In my studio I start with the stack of journal lists. I read each one and place it in one of the three piles that consist of the beginning, middle and end of the book. The pile I select for the journal page to be put in is determined by the story line or theme I have chosen. Once I have completed the large stack, I then go through the three piles and organize the pages in the order they will go into the book. This process has grown and been fine tuned over time. I have always enjoyed having a story line to the project I am working on, and this organizational method simplifies the project a bit.

If you have a small work space it can be hard to sort through lots of papers while working on your pages. Keep in mind the story line process is just a creative idea. You can also leave your journals in the stack the way you wrote them, or you can pick out a random journal list for your page as you go. How you organize your journal pages is completely up to you.

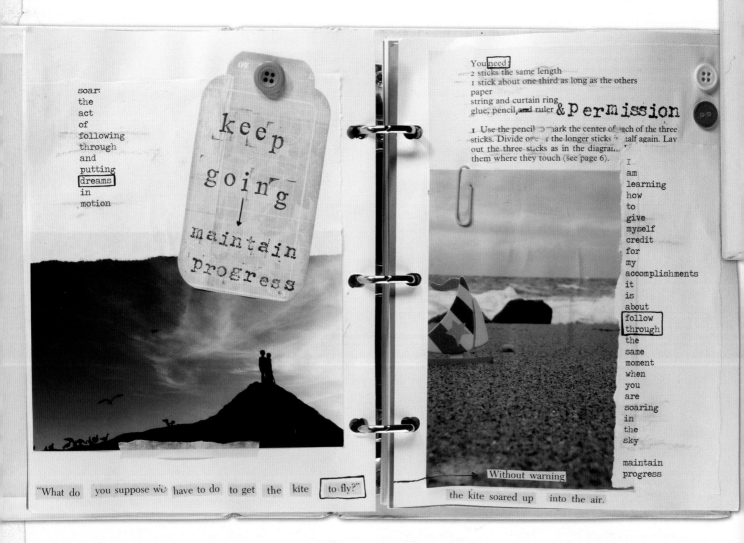

Visit **CreateMixedMedia.com/art-journal-art-journey** for bonus content.

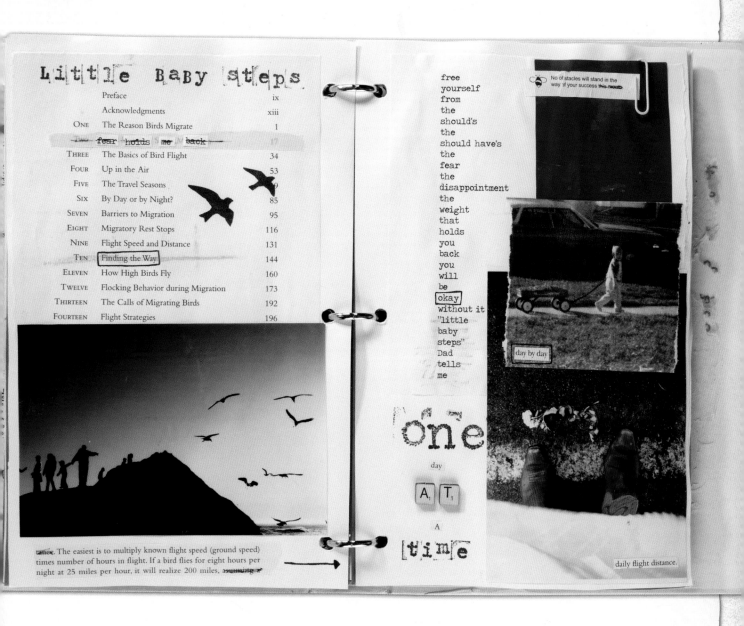

Little Baby steps

tance. The easiest is to multiply known flight speed (ground speed) times number of hours in flight. If a bird flies for eight hours per night at 25 miles per hour, it will realize 200 miles, assuming a

free
yourself
from
the
should's
the
should have's
the
fear
the
disappointment
the
weight
that
holds
you
back
you
will
be
okay
without it
"little
baby
steps"
Dad
tells
me

No obstacles will stand in the way of your success this month

one
day
A T
A
time

day by day

daily flight distance.

Create your story.

How to choose your materials

Most of the materials used to make the kites in this book may be found around the house. Choose covers and sticks that weigh as little as possible. The lighter the kite, the better it will fly.

Covers

Most kites have a cloth or paper cover but you can experiment with other materials. Whatever you choose, the wind must not be able to blow through it. Suitable materials are:

soaring

a
calm
mind
and
the
ability
to
ride
with
the
requires wind
correcting
direction
when
~~other things~~ : your
heart
tells
you
~~Glue~~ to
~~All purpose household glues will stick most of the~~
~~materials mentioned in this book.~~

4

Naples Yellow

Learn

allow your heart
to lead the way

your heart

it

{2} Preparing for the Creative Process

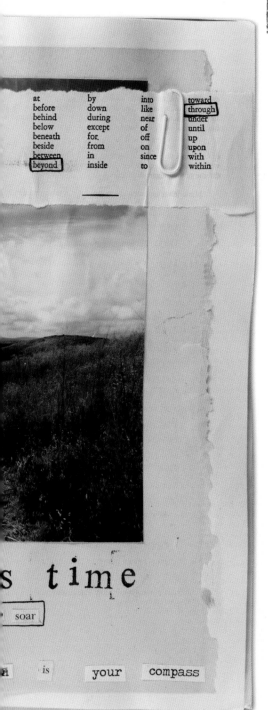

The creative process of art journaling is one of my favorite parts of this journey. The possibilities are endless when it comes to using your creativity. There is an entire world of art and craft supplies to explore and introduce yourself to as well as nontraditional supplies that you can use for creating your book. The creative boundaries stretch far and wide on what you can do at this time. Even though I am familiar with the supplies I use in my journals, I still become overwhelmed by having so many options. Remember, you are not alone and the feelings that come with trying something new can be a bit hard to navigate at first. We will start slow, introducing and collecting new supplies first, and enjoying the journey as we go.

Preparing for the creative process allows the "art journey" to unfold. I have not always prepared for this part of the process the way I do now. After creating four books, I found that collecting supplies, setting up my work area and taking time to collect my thoughts for the project give me a sense of confidence and direction. The initial work that comes with preparing for the creative process makes space for your creative spirit to evolve. I also have found that having a work space set up and having all the supplies you would like to work with makes the "creating" part enjoyable. You are able to "just create," and this allows your mind to relax. When I first started creating books I had piles of papers on the table and would lose my stamps and scissors under it all. I would often lose my focus because I would spend most of my time looking for supplies instead of creating. Over time I found that organizing my space has been the creative solution to making this part of the process fun.

This part of the creative process is enjoyable and relaxing for me. I can process thoughts and feelings from the day and unfold into a calm space where I can center myself and reflect on my day, goals, vision and journey.

In this section I will share with you the supplies I use, where I find these supplies, how to select a book to work in and how to set up your work space.

Get Ready for the Creative Process

The journey of the creative process is filled with possibility. The next step is to prepare for the creative collage process. This consists of collecting supplies and setting up your work space. There is no timeline for when you need to "complete" this task. Although as we go through this section, I know from experience that you will find excitement in collecting supplies and preparing your space to "start" your journal.

The creative process takes place while we are still journaling in a computer document. I find that I am often inspired while I am writing, and this will guide me in the direction I want to explore when looking for supplies. I may want to find books on the ocean, birds, flight, etc., depending on what theme I explore in my journaling. I spent the last ten years near the ocean, and am often inspired by this.

A common question you may ask is, "When do I begin collecting supplies?" The creative process coincides with the journaling process. When journaling, a time comes when I know I want to start creating my journal. I will look at my journaling process and see how much text I have collected. I may be in the middle of journaling or getting close to finishing my journaling when I start collecting supplies.

When collecting supplies there is not a set list for what you need to have, though I will share some of my favorite supplies that are useful and inexpensive that you can use to begin your art journal. Supplies can be collected at your local art or craft store, thrift stores, used bookstores, the dollar store or the craft section at larger retail stores.

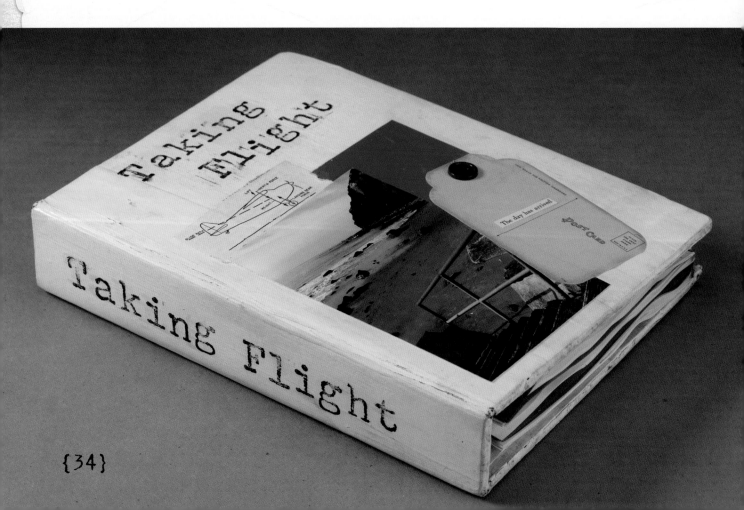

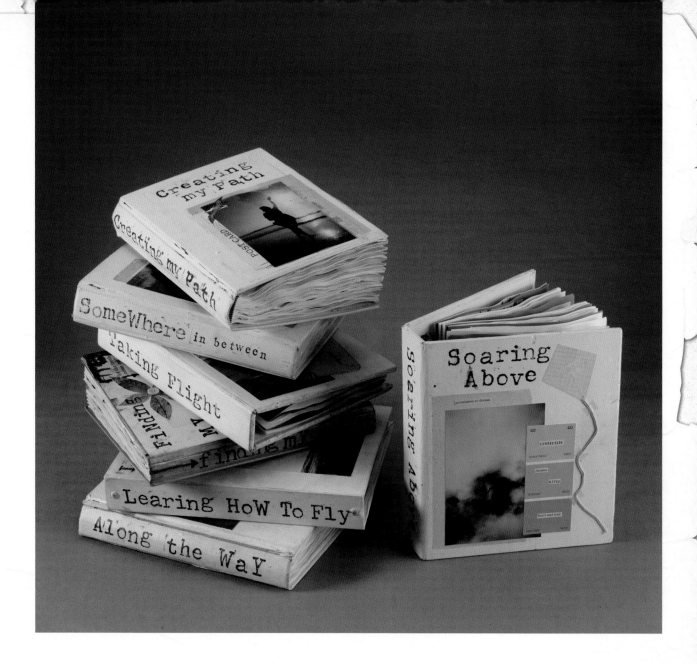

SELECTING A BOOK

For me, this is one of the most exciting parts of starting a new journal. Over the last ten years I have always chosen to work in an actual book I find at a used bookstore. In the last few books I completed, I chose to use the same style of book and located another copy online to work in.

Selecting a book is a very special moment for me. I know that I will be creating my journey in this book, and want to find a book I feel comfortable working in. When selecting a book, I look for a hardcover book that is a good size to use for a 4" × 6" (10cm × 15cm) photo on each page, as well as having a journal page. I enjoy working with a 8" × 10" (20cm × 25cm) book and have used this size for the last few books I have made. I have found over the years that it is challenging for me to work in a book smaller or larger than 8" × 10" (20cm × 25cm).

I do like to try different sizes and I currently have a book started that is a rectangular coffee table book with a spiral binding. It's working well as I explore my "By the Sea" theme.

There are many options for books that you can explore. For example, you can use a hardcover or paperback book from a bookstore; a blank journal that has a spiral binding, with lined or unlined pages; or a three-ring binder that allows you to create your own pages. You can work in a small or large book. Allow yourself time to find a book that you are comfortable with and want to create in. In the beginning you may be unsure of what you like working in, though your preferences will become evident as you go along.

Preparing the Book

Once you find a book that you would like to create in, it is time to pre-pare the book. During this step you will be preparing the cover as well as the inside pages that you will create on. This step allows you to make the book all your own.

MATERIALS LIST

hardcover book

craft knife

white glue

sanding block

gesso

paintbrush

PREPARING THE COVERS

1 Sand the front and back cover of your book to remove the gloss on the surface. Sand firmly enough to remove any writing or images you don't want to show through. Doing this also provides tooth for the gesso to stick to. Don't forget the binding!

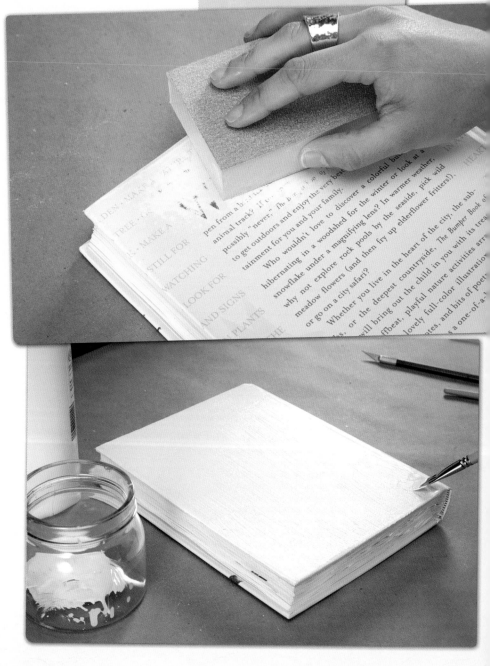

2 Paint two coats of white gesso on the front cover, back cover and binding of the book. Be sure to allow the gesso to dry between coats.

NOTE: The gesso will eventually start to chip off from general wear, though that has become my favorite look. If you would like it to stay white, cover the gesso with a decoupage medium, acrylic gel medium or other finishing product.

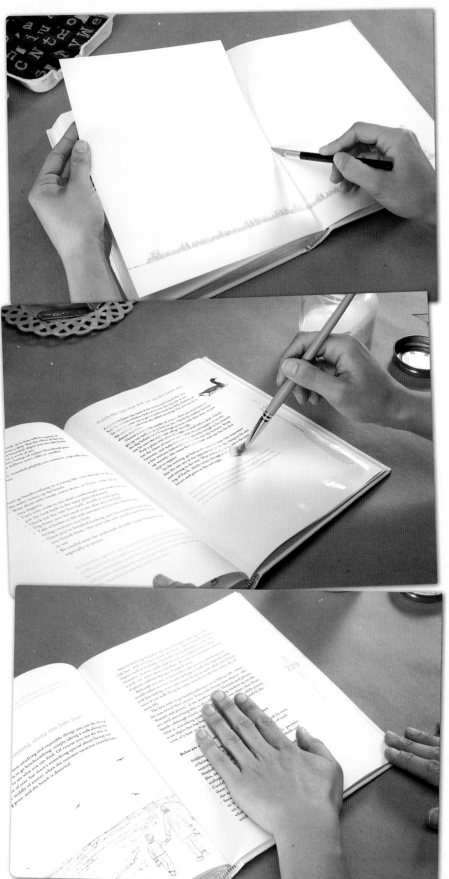

1 Use a craft knife to cut out sections of pages so there is room for the book to grow without breaking the binding when you add materials. When cutting out the pages, remove those that are unappealing to you or don't match your aesthetic. Here, I'm cutting out pages that have colored text because I only want black text.

2 Glue three or four pages of the book together to create a thicker space to work on. I'm using Elmer's white glue because I like the crinkled, organic effect it has on the pages. Feel free to experiment with other types of glue until you find an effect you like. Apply the glue around the edges of the page and in an X shape in the middle.

3 Press the glued page to the next page. Applying pressure from the binding and working outward. Repeat the gluing process on one more page so you have three pages glued together.

Collecting Other Supplies

Collecting supplies is the adventurous part of this journey. The possibilities are endless when it comes to what you can use in your journal. I never know what I will find. I often discover new things that I can use to create with; it can be as simple as using paint samples to add colors to finding one-of-a-kind items like vintage postcards.

Once you begin this process, you will start to notice more things you may have around the house that you can use, such as old books and maps you can cut words out of or use for page backgrounds.

A trip to your local art or craft store can be a exciting way to introduce yourself to all the supplies that are available. It might be overwhelming at first because there are so many options, though I find it useful to take an evening and spend time exploring. I also find it helpful to make a list of things you may be looking for or that have been used in this book, or even bringing this book with you for inspiration. Some days you may not feel like buying anything, but try using the opportunity to see what kind of supplies are available.

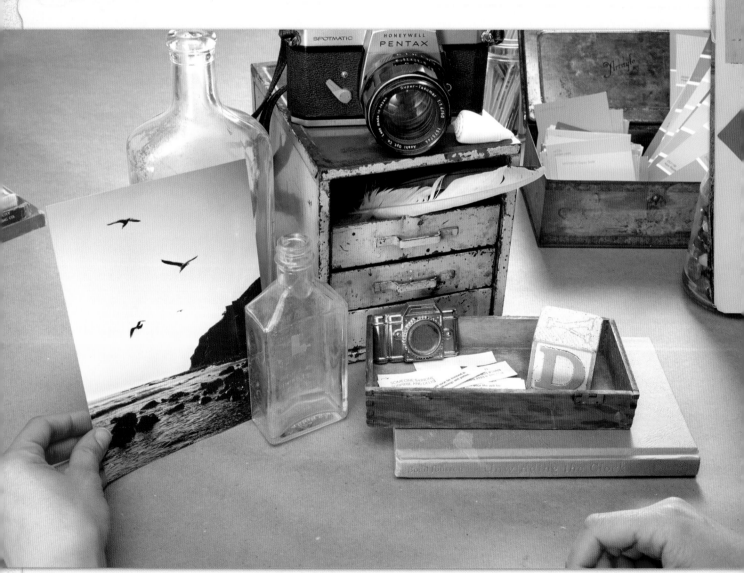

Visit **CreateMixedMedia.com/art-journal-art-journey** for bonus content.

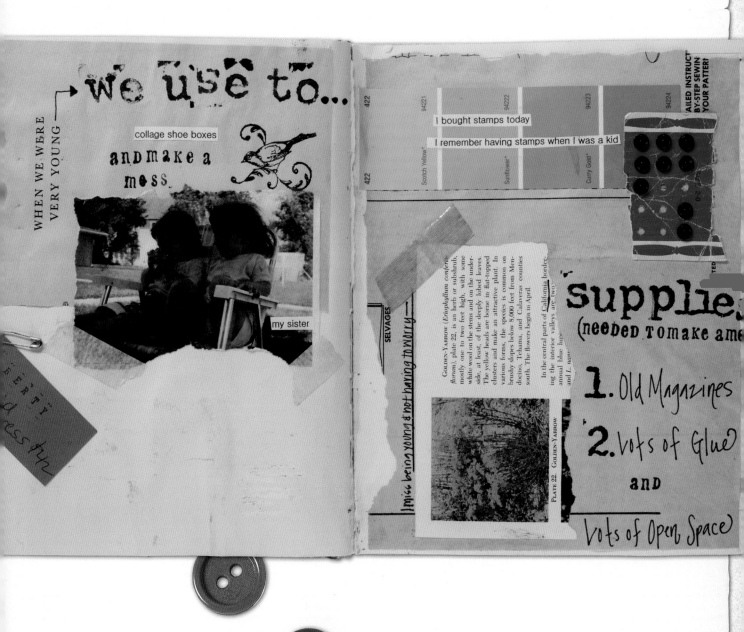

we use to...

WHEN WE WERE VERY YOUNG

collage shoe boxes

and make a mess.

my sister

I bought stamps today

I remember having stamps when I was a kid

422 94221 Scotch Yellow* 94222 Sunflower* Curry Gold* 94223 94224 422

supplies
(needed to make ame

1. Old Magazines
2. Lots of Glue
and
Lots of Open Space

Setting Up Your Creative Space

Over the last five years I have learned through experience that I create freely when I have set up my creative space and organized my supplies. When I first started collaging in books there was no order to my supplies. I love creating beautiful messes, but I would often spend most of my time looking for my scissors or supplies that would get lost in the piles of papers on the table. Through experience I found that old boxes and jars help keep my supplies organized and allow me to enjoy the process of creating.

An easy way to arrange your space is in a *U* shape with small tables on either side of you for supplies you want easy access to but don't want cluttering up your work space. Keep the area directly in front of you clear for the project you're working on at that moment. If you work in a small area like I do, use side tables that are short enough to slide under your main worktable.

Spend some time finding boxes and jars and eclectic dishes or trays to put your supplies in. My personal style is old, vintage wooden boxes and mason jars. Set up your work space in a way that is inspiring for you. Arrange old books, from which you can draw inspiration and cut out words, to spark your creativity.

Create beautiful messes.

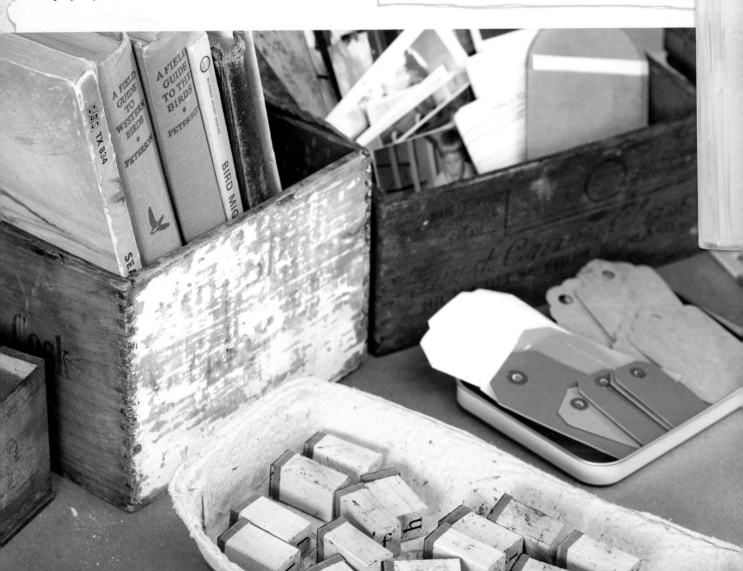

PHYSICAL DESCRIPTION

The name southern California is arbitrarily used here to designate the arid parts of the state from San Luis Obispo County southward to the Mexican border and eastward to Death Valley and the Colorado River. The southernmost Sierra Nevada is not included. Other volumes of this series may vary in the exact geographic area covered.

Southern California comprises oceanic islands, sea-shore, coastal plains, great inland valleys, and internally drained basins with east-west and north-south dissected mountain ranges between. There are many low hills, some isolated, others seemingly buttressing the mountains. The northward islands owe their existence to subsidence of the western end of the east-west directed Santa Monica Mountains.

Between the mountains and the sea, the coastal plain varies from rather wide to narrow, sometimes extending inland and cut across by a few small streams, such as the Santa Inez, Santa Clara, Ventura, Los Angeles, Santa Ana, and San Luis Rey rivers. Most of the larger valleys and some of the upland slopes are devoted to agriculture and urban development

Much of San Diego County, except for a rather narrow strip of marine terraces and geologically young

need
to
tuck
into
our life
build
our
foundation
create
the
love

most
need
to
find

GREETINGS from CALIFORNIA

A gay old sport is the SEAGULL
This particular one is a HEGULL
He goes on long flights
For days and for nights
It's kind of hard on his wife the
SHEGULL

am finding who I am and what i want

CALIFORNIA SPRING WILDFLOWERS

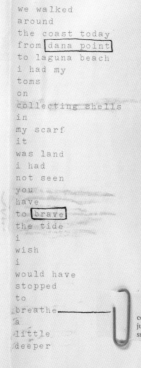

we walked
around
the coast today
from dana point
to laguna beach
i had my
toms
on
collecting shells
in
my scarf
it
was land
i had
not seen
you
have
to brave
the tide
i
wish
i
would have
stopped
to
breathe———
a
little
deeper

Going Where The Sun

BEACHCOMBING

For a hobby that combines exercise and fun, beach-combing is hard to beat. It is especially rewarding just after a storm, when interesting natural treasures such as sea shells and driftwood are washed ashore.

Sets On The Water

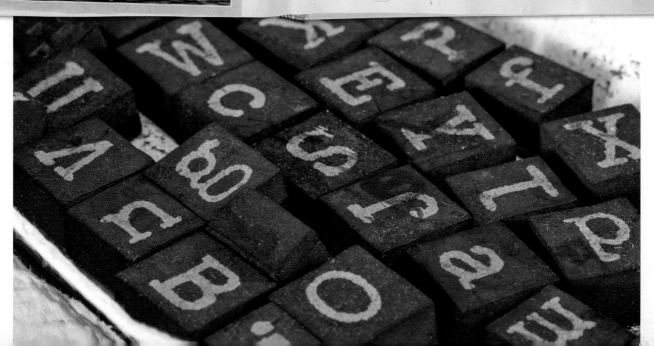

Old Book Text

I have a love for old books. I create my journals using old books for words, illustrations and the pages. Looking for old books is an adventure; you never know what you will find and you get to explore thrift shops, used bookstores and even your own book collection. Many of the books you will find will be anywhere from twenty-five cents to maybe ten dollars a piece, depending on the shop. I often look for books that were published before 1970 because they tend to have more black-and-white illustrations.

I started using old books to tie in abstract themes in my journals. For example, when I was working on my journal "Along the Way," I was living in California and wanted to explore books on the ocean and California to tie in with my personal journey while living there. Some of the other themes I have explored are birds, bird migration, flight, wildflowers, sailing, navigation, using a compass and old music books.

When looking for books you can set out with some themes in mind that may interest you or take a day and browse through the shop to see what you will find. Use these books for full-page backgrounds in your journal or use the illustrations or text.

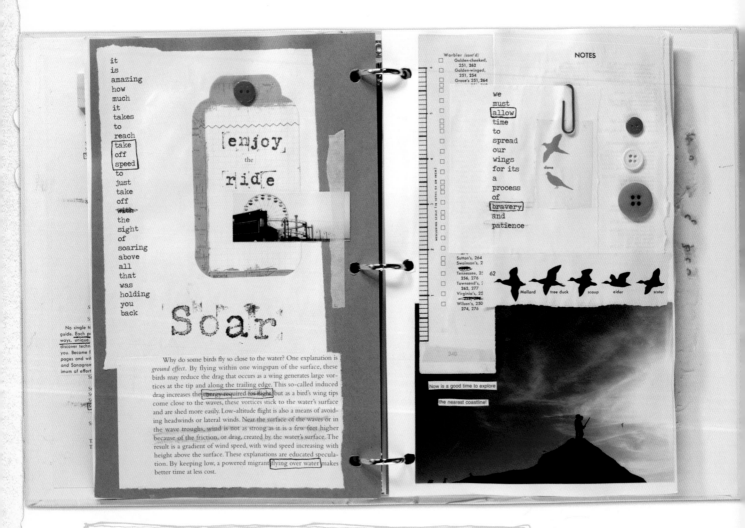

Take an adventure.

Visit **CreateMixedMedia.com/art-journal-art-journey** for bonus content.

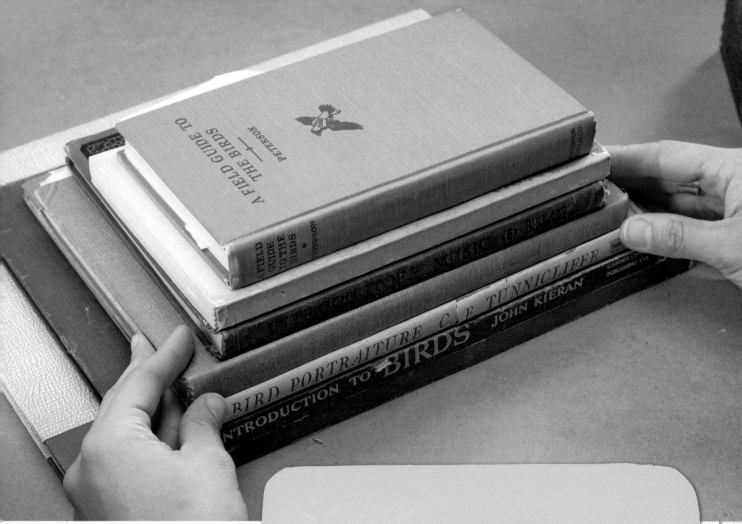

ADVENTURE

Take a day and check out your local thrift stores, antique stores and used bookshops for old books you can use to decorate your creative space or use in your journals.

Some shops will have the books organized into categories and some will not, making those shops giant treasure boxes. When shops have categories, begin to explore areas that interest you as well as the other sections you may not normally look at. I love looking through the travel, nature and reference books (encyclopedias and dictionaries) along with random categories such as fiction and personal growth. I find that personal growth books often have inspirational words that you can tie into your journal. Also, many used bookstores have a bargain book section where you can often find unique books.

Collecting and Organizing Photos

I have been taking photos for as long as I can remember. I have a love for photography and capturing my life through photos. One of the common questions I get asked is about the camera I use. I have a Canon DSLR camera, though I usually shoot on auto settings and I also use my smartphone camera. My phone is always with me, allowing me to capture the little things I find along my journey. I love capturing the feathers and heart shaped rocks I find, the sunlight, my cup of coffee and my running adventures along the shore. The beauty of digital photography is that it allows us to take lots of random photos of our days. Over the years my eye has evolved and I have become more attuned to my surroundings and capturing these images.

In most of my book layouts I use one photo per page and work in a fifty-page book, so having a collection of at least one hundred photos creates an assortment to choose from.

You can also use photographs that you already have printed. I have created a few books using old photographs from when I was younger. I used a scanner/copier to make copies to use in my books and kept the originals in good condition.

Collecting your photographs is a creative little side project. Start a folder on your desktop and add photos that you want to have printed. Once you collect at least fifty to one hundred photos, print them out. Printing them at a photo center provides better quality than an at-home printer.

Once you print your photographs, use a basket or a shoebox to organize them. Using sticky notes to create themed sections of the box, for example "Ocean," "Fields," "Misc. Photos," makes finding a photo easier when you have an idea in mind for a page you are working on in your journal.

ADVENTURE

I love photographing my day-to-day adventures. Since I often have my smartphone with me, I will use its camera to capture anything that catches my eye.

This is a great way to build your photo collection. Take an adventure to a downtown area and explore the city landscape. Go to your local park, historic parts of the city or even your own neighborhood; these are great places to capture unique images. You may also have photo opportunities in your own backyard.

Be inspired.

Some things you can look for when you take a photo excursion: wide open spaces, fields, historic buildings, leaves, trees, the ocean, trails, the sunlight or anything else that catches your eye.

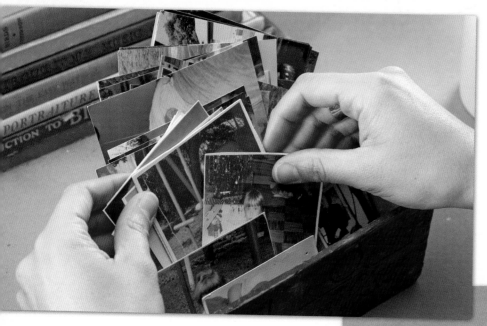

Collect photos.

Organize into categories.

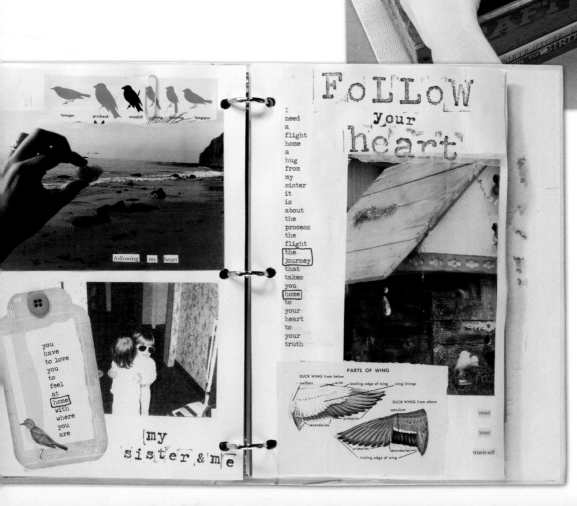

FoLLoW your heart

I
need
a
flight
home
a
hug
from
my
sister
it
is
about
the
process
the
flight
the
journey
that
takes
you
home
to
your
heart
to
your
truth

following my heart

you
have
to love
you
to
feel
at
home
with
where
you
are

[my sister & me]

PARTS OF WING

DUCK WING from below
axillars wrist leading edge of wing wing linings

DUCK WING from above
speculum
primaries
secondaries
primaries
secondaries
trailing edge of wing

revel

your

truest self

Stamps

One of my favorite supplies is rubber stamps. I use stamps in my journals to emphasize a theme, word or feeling I am exploring for that page, as well as to add a visual element.

There are a variety of alphabet letter stamps in different fonts and sizes along with all kinds of designs. In my studio I have small, medium and large alphabet stamp sets, allowing me to mix and match when adding words to my journal page. The largest size I have is about 1" (3cm) tall. My favorite font style is typewriter, though there are all kinds of designs.

Along with letter stamps, I have a small collection of image stamps that I can add to a page. My collection consists of birds, feathers, leaves, flowers and some unique styles such as a postage stamp. I use these stamps to create collections of work by adding them on different pages to create a common theme.

When looking for stamps, you may have to visit a few different shops or look online to find designs that inspire you. The possibilities are endless when it comes to rubber stamp designs.

Collect your vision.

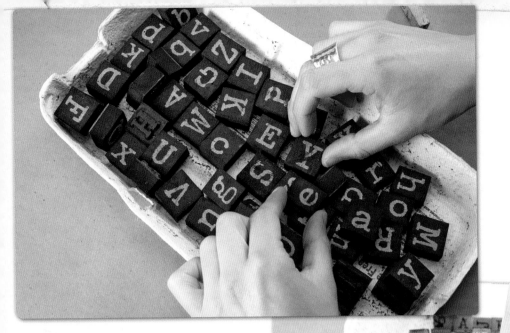

Find a tray or use the top of an egg carton to arrange your letter stamps so you have easy access to them.

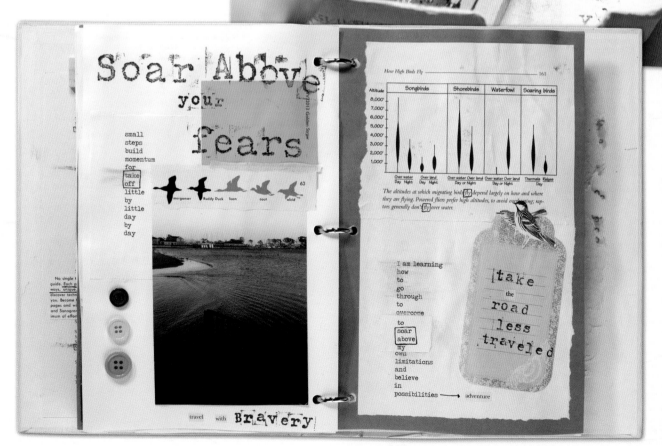

Glue

Along my art journaling journey I have discovered certain supplies that work well. When it comes to collaging papers into my journals I have found that using a paintbrush and white glue poured into a jar works best for me. I will use the lid from the jar as a place to rest my brush when I am not using it. I use a basic white glue that you can find in the stationery or office supply section. I like the thinner consistency of a white glue; craft glues are much thicker and do not move well on paper.

Using a paintbrush and a basic white glue allows you to cover the paper or back of a photo evenly with a thin layer, making it easier when gluing your items down. Since we are working with mostly papers or small items such as buttons, it is not necessary to use a thick glue. A basic white glue will dry quickly so you can move onto the next page in a short period of time, if that's what you want to do. Another option is using a good quality glue stick, which will dry very quickly. Glue sticks are great if you will be traveling and working on your journal since they are small and easy to carry with you.

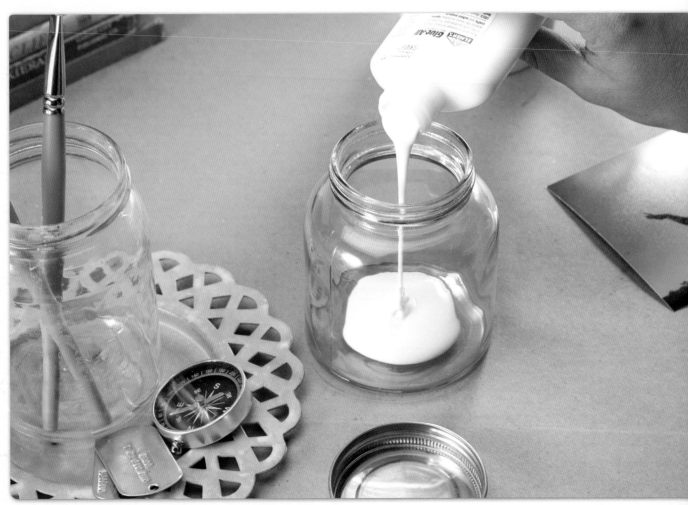

Instead of using glue straight from the bottle, pour it into a wide jar so you can dip your paintbrush into it.

Visit **CreateMixedMedia.com/art-journal-art-journey** for bonus content.

Little Bits

I love adding what I call "little bits" to my journal pages to add color. These little bits consist of buttons, paper clips and paint samples.

At your local craft store you can find all kinds of different sizes and colors of buttons. When using buttons you want to make sure the back side of the button is flat, making it easier to adhere to your page. Some buttons that are used for coats have a shank on the back that prevents the button from laying flat. You also can go to thrift stores or even ask family or friends if they have buttons they are not using. I was given a few jars of buttons over the years that I have put to good use.

I also enjoy using paper clips in my journals. They can serve both as decorative and functional elements to attach tags or other pieces of papers. You can find all kinds of colors, designs and sizes of paper clips in the stationery or office supply section.

Another fun element that adds color is paper paint samples. You'll find a variety of sizes and styles of paper paint samples that you can use in your journal. Stop by your local hardware store and pick up a few different paint samples that you may want to use in your book.

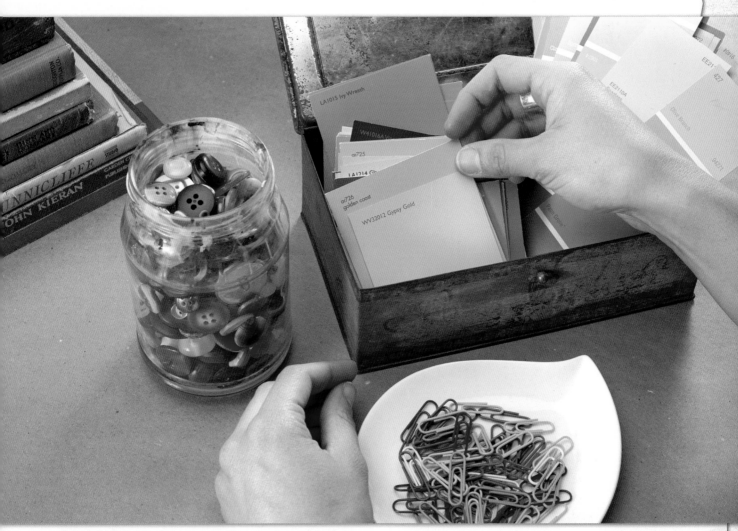

Gather the little bits that you can add to your journal: buttons, paint samples and paper clips, and arrange them in jars, boxes and dishes.

Scrapbook Bits

I am always looking for new things to use in my journals. The scrapbook section of your craft store is a great place to find popular and trendy items you can use in your projects that are usually sold in large quantities. I collect paper tags, envelopes, small blank cards and paper that I can add to my journal page. The scrapbook section offers all kinds of fun things to add to your journal.

Take time to explore this section because there are a lot of options to look at. I find it helpful to do some "creative collecting" first to get an idea of what is available. You can use your camera on your phone to take photos of items you find before you purchase them and then go home and see if they would work well in your journal.

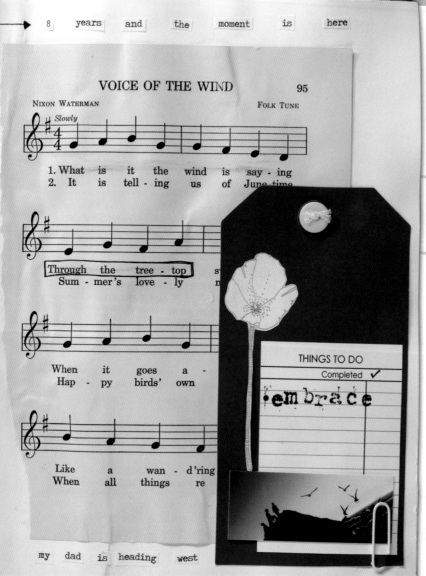

Collect your story.

Postcards

Over the years of collecting supplies I have discovered some unique items that I can add to my journal. One of these items is postcards. You can find postcards when traveling or even vintage postcards at your local thrift shop or used bookstore. When traveling for this book I discovered a shop that was selling old postcards that had vintage stamps and handwritten messages. Seventy postcards later at ten cents a piece, I was ready to begin collaging.

Postcards offer two sides to work with. You can use the design on the front or the blank space on the back to add your own words with your rubber stamps or a handwritten message. You can even add postage stamps to decorate them.

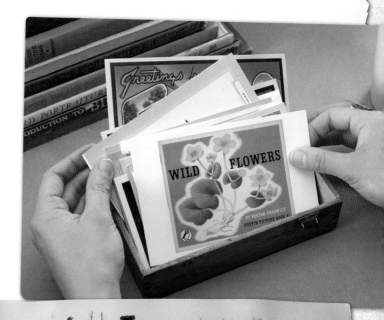

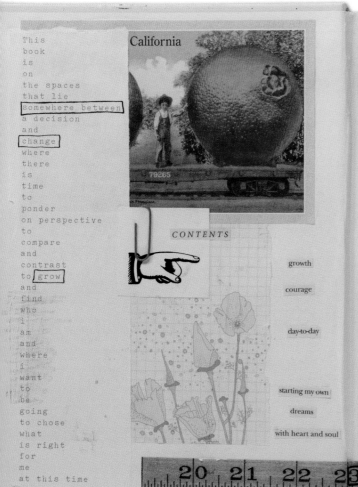

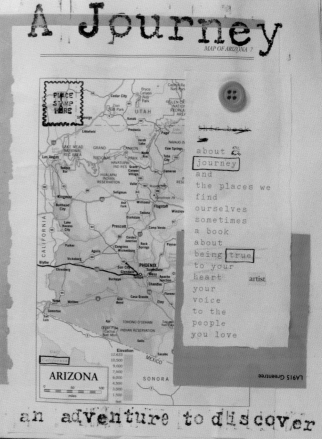

Live your journey.

Pens, Markers and Oil Pastels

I have a collection of pens and other supplies to add color or highlight words. Some of my most frequently used supplies are fine-tip black ink pens and a set of oil pastels.

I usually do not use specific brands for these items, but over the last year I have found that I like the style of the Stabilo fine-tip pens as well as the fine-tip markers. They're comfortable to use and hold, and provide a quality result of ink on the paper. Some of my favorite marker colors are teal, gray, maroon, olive green and dark yellow.

I love my set of oil pastels. I use these to highlight specific words and add bits of color to my pages. These do not require a drying time and you can use your finger to smudge the color on the page to blend it in.

These supplies can be found at your local art and craft shop or even at an office supply store. You may already have pens you can use in your journals.

Add any kind of pens, markers and colored pencils and crayons to your supply collection. I like using these supplies because there is no required dry time.

Find colors and supplies you enjoy creating with and add them to your collection.

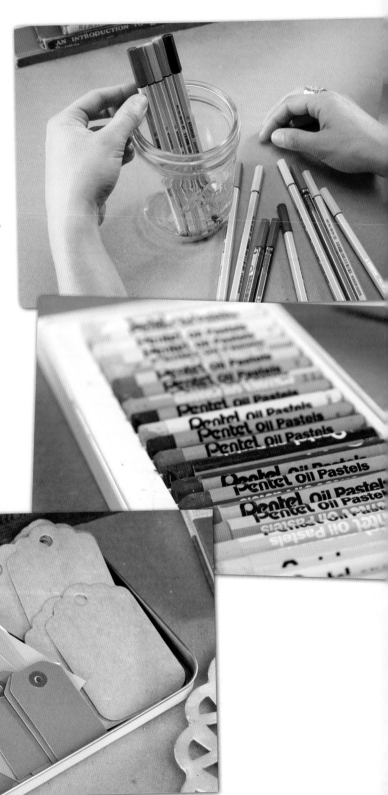

Visit **CreateMixedMedia.com/art-journal-art-journey** for bonus content.

Tapes, Scissors and Other Supplies

In my collection I also have some basic supplies that I use in my journals. I love layering papers and enjoy using different tapes in my books to adhere papers together or use as little decorative elements. My favorite style of tape is masking tape. It's inexpensive and I enjoy its neutral color and vintage feel. Masking tape also comes in various colors and widths.

At your local craft store you can find all kinds of decorative styles of washi tape, or Japanese paper tape, that you can use to add color or interesting designs to your page.

When using scissors, I find that a small set works the best. I have a pair in my supply collection that has a fine-pointed tip at the end, which allows me to cut small images such as birds or flowers from old books.

Gather jars and fill them with your brushes, frequently used pens and scissors. Collect different types of tape like drafting tape, masking tape or washi tape.

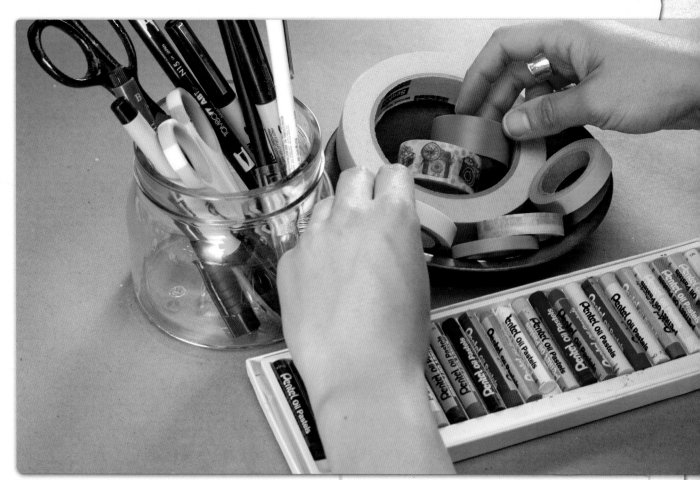

There are different shades of masking tape and I always look for a kind that has a vintage look. I do the same thing with washi tape; I look for rolls with neutral colors or patterns.

Collage your journey.

Loose Paper and Ephemera

In my studio I have boxes of loose paper and ephemera that I can use in my journal. I collect this paper from old books, using the front and back blank pages as well as using paper from blank journals or notebooks. I also have index cards, small sticky note-size paper and large 8½" × 11" (22cm × 28cm) paper that I can tear down for a smaller size.

Along with my box of plain paper I am always collecting different images from old books as well as unique decorative pieces you can find in the scrapbook section of your local craft store. I have a collection of vintage bird images as well as flowers, postage stamps, old sewing patterns and bits of paper from a dictionary and thesaurus. I am always looking for old books that have illustrations in them as well as vintage paper that I can use.

Find bits of paper or notebooks that you can tear pages out of to add to your journal. New journals with paper that looks vintage can be a great resource if you don't have a used bookstore or vintage shop nearby.

TIP

If you find an old book or notebook at a used bookstore and want another copy to use for another book, visit Amazon.com or Abebooks.com. You can usually find plenty of duplicates there.

As you work on your books, you'll collect scraps of paper, postage stamps from letters and copies of meaningful photos. Arrange those in a box and lid so you can easily locate them.

Inspirational Life Ephemera

After I have collected my supplies to use in my journal I will find a few things to place on my table for decoration. I always enjoy having little things to inspire me as I create.

When working on my journals, I have found that having sentimental items that bring a sense of comfort inspire the journaling and creative process. When I work on my journal pages there are times that I may be having a creative block, and these things can often inspire a creative vision or feeling.

Here, I propped up a vintage camera with some seashells, a picture of seagulls flying and a D block that reminds me of my dog, Dakota. These are the things of sentimental value that I can look at, refer to and spark my creative spirit.

Find a few things that you cherish and add those to your space. Let this step of the process come naturally. If you are drawn to have something on your table, add it, though if you want just your supplies that is perfectly fine as well.

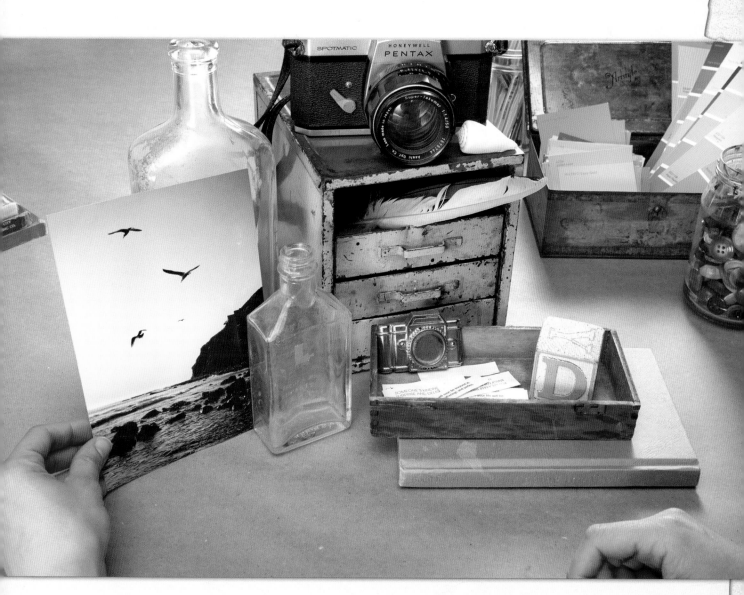

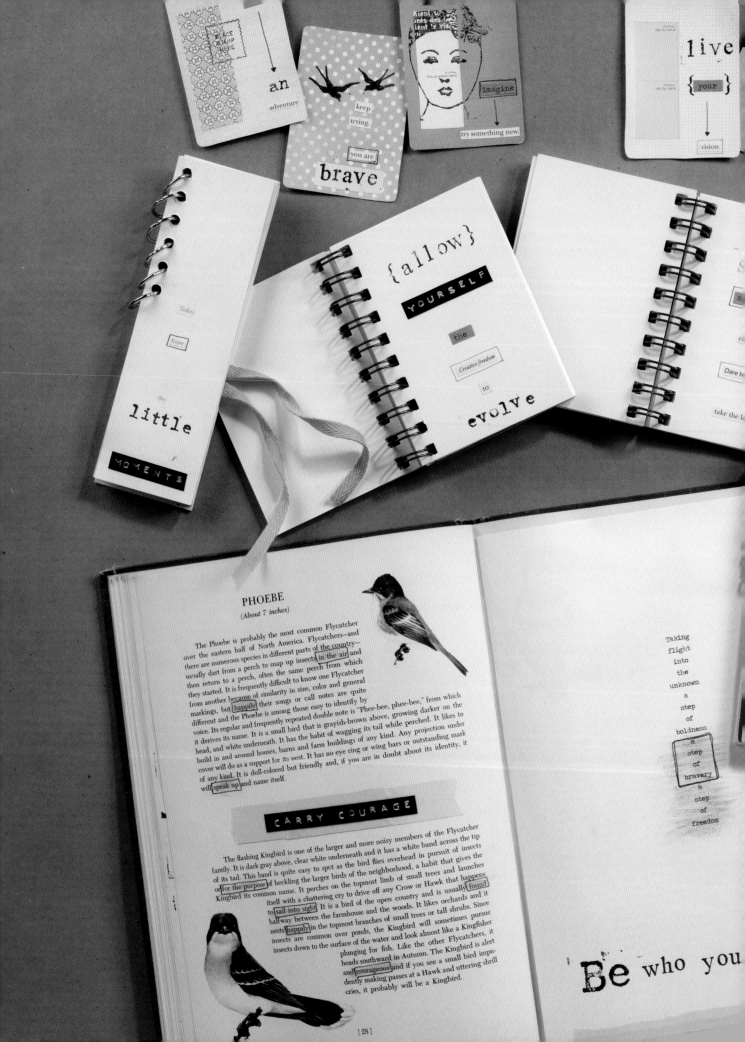

A Creative Adventure:
MINI PROJECTS

Working on a mini project while you are in the process of collecting and gathering supplies for your main project is a great way to be creative during this process. This is an opportunity to explore different techniques and materials. I use mini projects to inspire my creativity and to help jumpstart the creative process. When working on a mini project I find if I start with a small project that allows me to use my art supplies and explore my thoughts, it can often be the leap I need to take to start my larger book project.

The beauty of a mini project is that you can start, create and finish something in a short period of time. A sense of accomplishment can be very inspiring and often gives you the confidence and bravery you need to move you forward on your journey.

With mini projects it is important to take a simple approach that will allow you to create without having expectations. During this time it is important to give yourself permission to explore your own style and to try new techniques and supplies. It is about creating and having fun along the way.

Mini projects can be created from any medium. I have used old books, a deck of cards, small journals, individual canvases and postcard-size paper.

In this chapter we will create three mini projects: an inspirational card deck, a mini word journal and an altered book.

Inspirational Card Deck

An inspirational card deck is a fun mini project that gives you an opportunity to create fifty-two individual pieces of art. These small cards allow you to explore a smaller working space, and help take the pressure off of creating a large project. This project can be created on a daily basis, designing one to three cards at a time. Here you are able to experiment working in a nonbook-style format. I use this project to focus on positive affirmations through found text. I often keep my finished cards in various places in the house or studio to remind me of the simplicity of how meaningful creating art can be and how holding onto positive affirmations can provide inspiration, strength and motivation throughout my day.

Intention for this project:

Use your supplies to create positive affirmation cards.

MATERIALS LIST

deck of cards with an appealing or decorative background

scrapbook paper

strong-hold tacky craft glue

scissors

alphabet stamps

decorative image stamps

black ink pad

Stabilo fine-point pen

paintbrush

inspirational books or magazines

TIP

You could use artist trading cards, uniformly sized greeting cards or blank business cards.

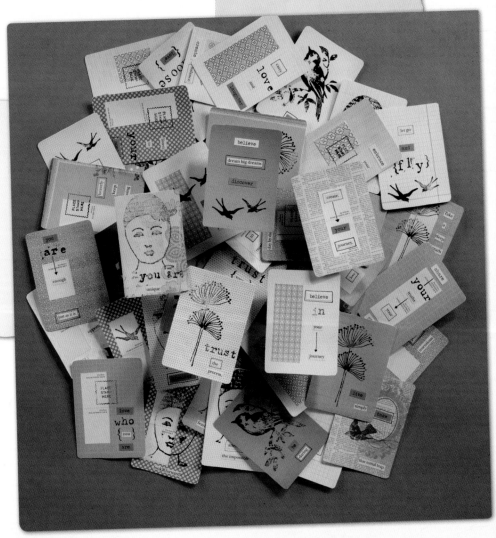

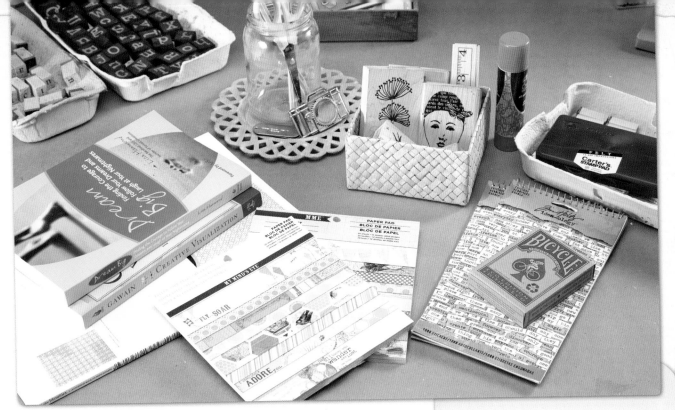

1 Gather the supplies you have collected for this project and arrange them in your studio space.

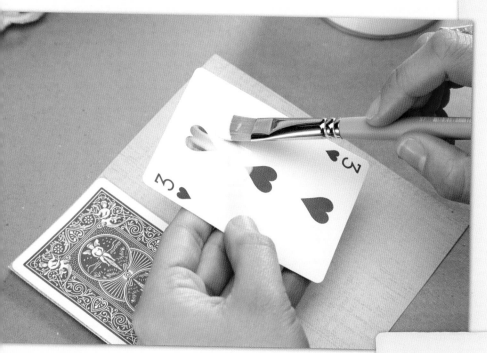

2 Prep all of your playing cards with scrapbook paper. Brush a layer of craft glue on the number side of the card.
 I like to use the face of the card (the side with the suit and number) for my working surface, leaving the pattern side blank.

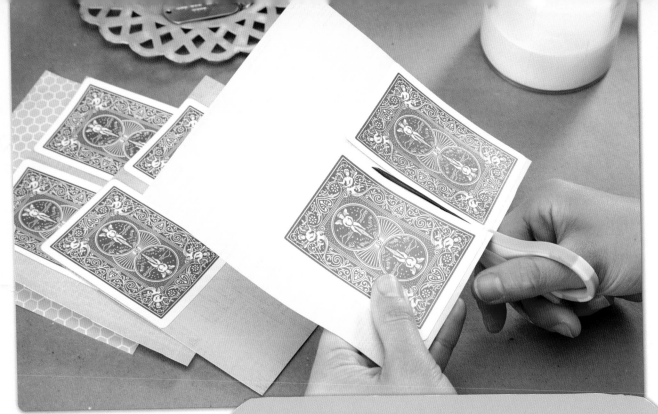

3. Place the card on a piece of scrapbook paper. Repeat until the paper has as many cards as will fit.

Repeat with the entire deck of cards. Allow the glue to dry and cut out the cards. When beginning this project, you can work with one card at a time or prepare multiple cards at once. Creating one card at a time works well for me.

TIP

Make sure to adhere your card to the side of the scrapbook paper that you want to cover, so when you cut out your card, the side you do want to see faces out.

NOTE

This project is full of freedom. Embark on a creative journey; let your heart guide you and draw focus to words that inspire to you. Let your creativity flow and give yourself space to let the designs evolve. You are creating these cards for you; quiet the voices inside that may be holding you back from creating freely. Fear, perfection and worry can clutter our minds when we are working on something new. Make yourself aware of these voices and quiet them with positive affirmations.

When working on this project you can choose a theme or leave it open to evolve as you create. You can focus on the words, color or ephemera you have collected to determine your card's theme.

THEME IDEAS:
Positive words
Quotes
Affirmations
Found poetry

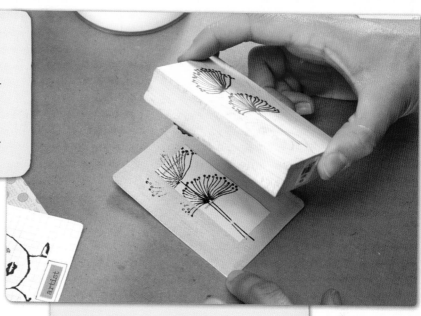

4 Cut out small, rectangular pieces of paper with different designs that match the scrapbook paper backgrounds. Glue one to the center of a card or slightly to one side of a card.

Use a large rubber stamp and black ink to add another design element.

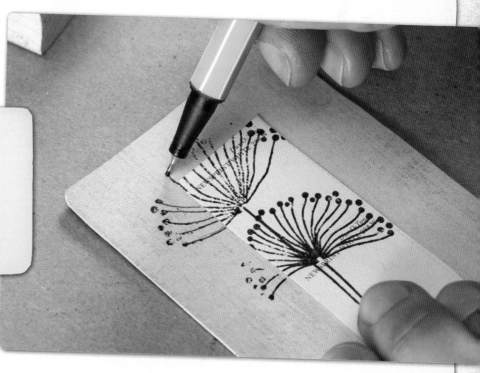

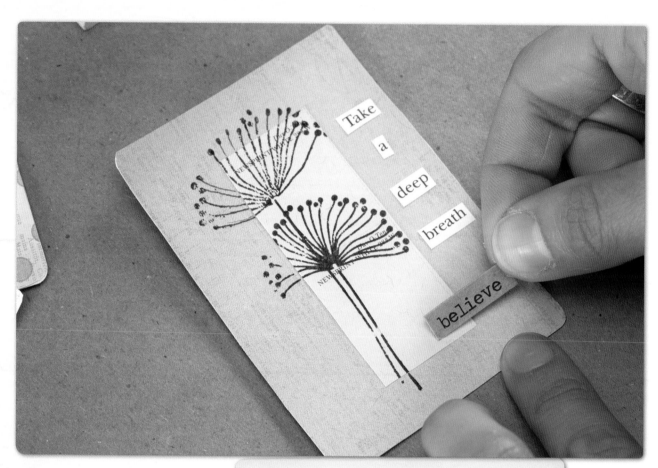

5 Cut out words from a book or use word stickers to add inspirational phrases along the side of the stamp.

If you want one word to stand out more than the others, choose it from a sticker book with a colored background or from a book/ magazine with colored fonts or paper.

If you do not have the word you are looking for, use your rubber stamp set on your card. This is a fun way to add a unique element to the card. If you make a typo using your rubber stamps, you can cut out a mini piece of paper to cover that area and then stamp again on top of it.

TIP

I use a small plate to gather together the cutout words. This helps me keep them organized and to see what words I have to choose from when designing a card.

POSITIVE AFFIRMATIONS

I am strong
I am confident
I am brave
I am beautiful
I am creative
I am an artist
I am moving forward
I am becoming
I am evolving

Visit **CreateMixedMedia.com/art-journal-art-journey** for bonus content.

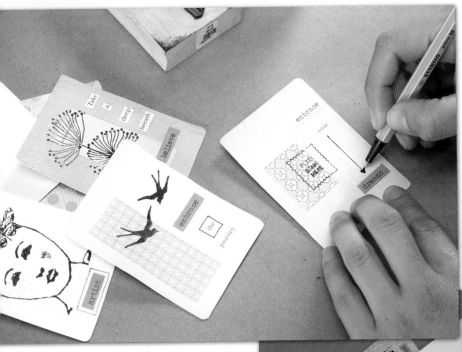

6 Call attention to a particular word by placing it farther away from other words and drawing an arrow to it, or drawing a box around it with a black pen.

TIP

Keep these cards around your house, in your car or at work to inspire you, or carry them with you to share with others.

You can attach these cards to your business card with a paperclip, or even frame a few of them together to create a piece of wall art.

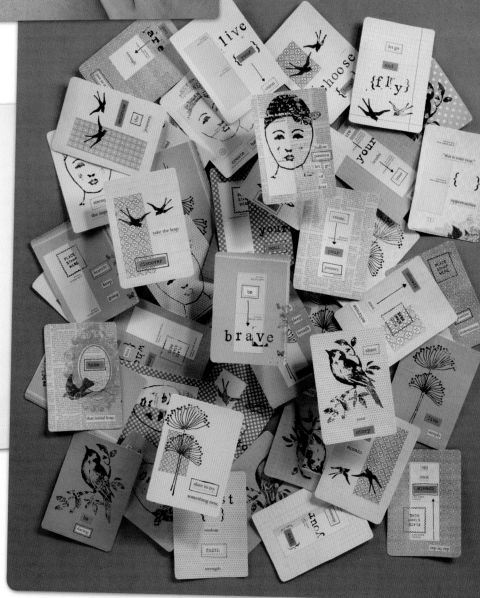

"Words I Carry" Mini Word Journal

Creating a mini word journal is a great way to explore your heart and thoughts through words. This project is simple in that there is not a lot of surface space to cover. Once you finish one page you can flip to the next, allowing you to come back or start something new in a short period of time. I use mini journals to explore my thoughts through simple list poetry. I find words in old books and use rubber stamps and a label maker to create the other words I may need. I fill these mini journals with positive affirmations that can inspire creativity.

Intention for this project:

Use your supplies to create short list-style journals or affirmations to explore your theme of choice.

MATERIALS LIST

small wire-bound notebook

inspirational books

Dymo Organizer express label maker

alphabet stamps

ink pad and re-inker, black

fine-point Sharpie pen

magazines

word stickers

Stabilo fine-point pens in a variety of colors

glue or glue stick

scissors

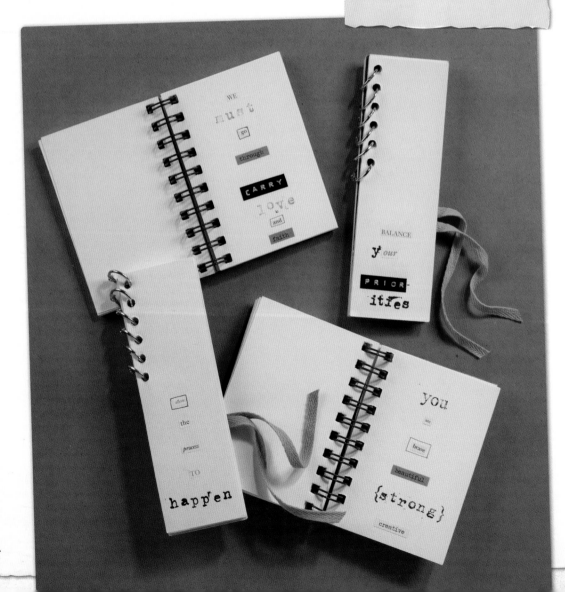

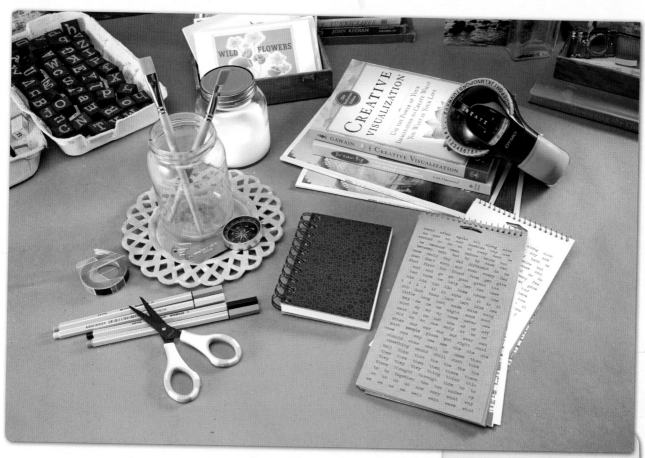

1 Set up your work area with your supplies. Put on your favorite music and pour yourself a cup of coffee or tea.

Choose a theme that you would like to explore in your mini journal. Find inspiring personal growth books with positive words you can use. When you find words or phrases that speak to you, create affirmations with them using the following techniques.

TIP

I find that a creative environment carries into a creative mindset.

THEME IDEAS

Your personal journey
Affirmations
Your vision, thoughts or feelings
Spontaneous found poetry lists

Found poetry is when you take existing text and rearrange and reorder the words into your own poem.

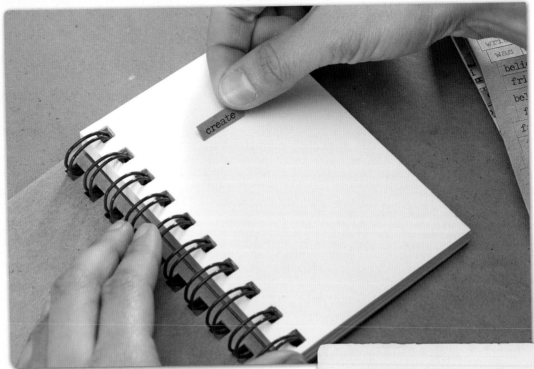

2 Begin with the wire-bound notebook and open it to the first page. Choose a word from the sticker collection and adhere it to page.

TIP

I like to place the words on the page first and move them around to decide where I want them. Sometimes I will center them or leave space in-between.

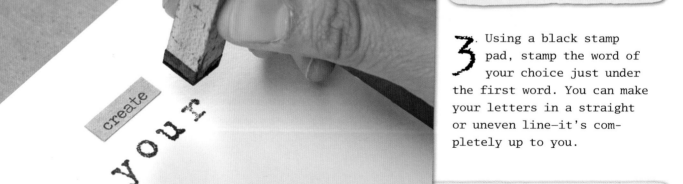

3. Using a black stamp pad, stamp the word of your choice just under the first word. You can make your letters in a straight or uneven line—it's completely up to you.

TIP

Your list poems can be as long as you want them to be. Some pages may have only one word on them.

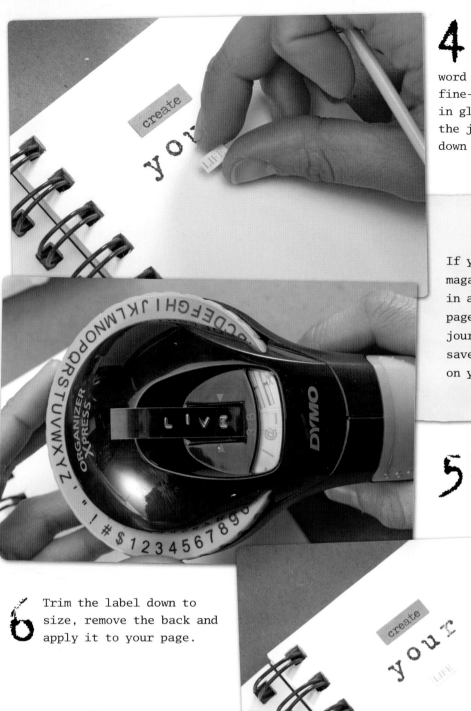

4 Cut your next word out of a magazine. Apply glue to the back of the word using a glue stick or a fine-tip paintbrush dipped in glue. Place the word on the journal page and press down to adhere.

TIP

If you find a word in a magazine that will fit in a poem for another page in your mini word journal, cut it out and save it in a small dish on your work space.

5 Make your next word using a label maker.

6 Trim the label down to size, remove the back and apply it to your page.

TIP

The label maker tape is wide, so I typically like to have these made before I glue down the cutout words to make sure I can fit them in the available space.

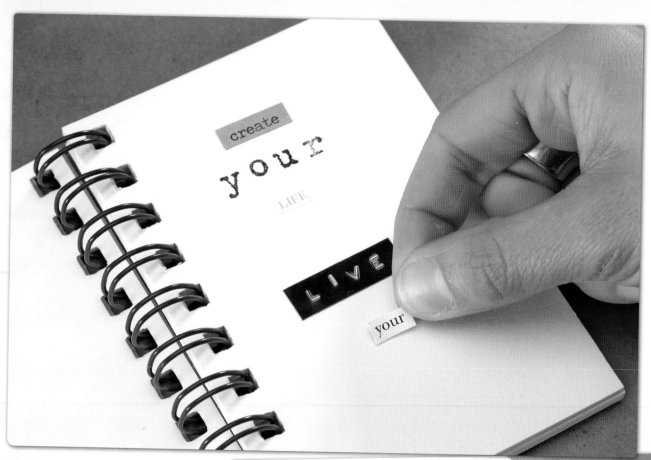

7 Cut the second to last word out of a book, apply glue with a glue stick and press it into your mini word journal under the previous word.

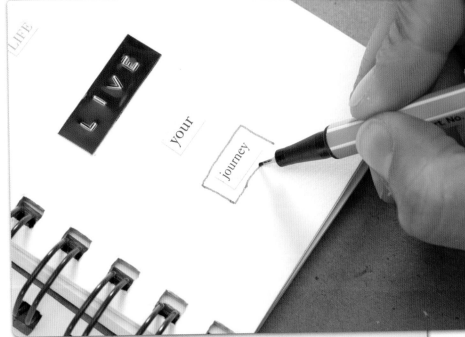

8 Apply your final word using one of the previous methods shown. Emphasize this word by drawing a box around it using a fine-point pen in a color of your choosing.

Turn the page and repeat!

TIP

I like to use my pens to emphasize the cutout words or words created by the label maker since they have a straight edge to follow.

Visit **CreateMixedMedia.com/art-journal-art-journey** for bonus content.

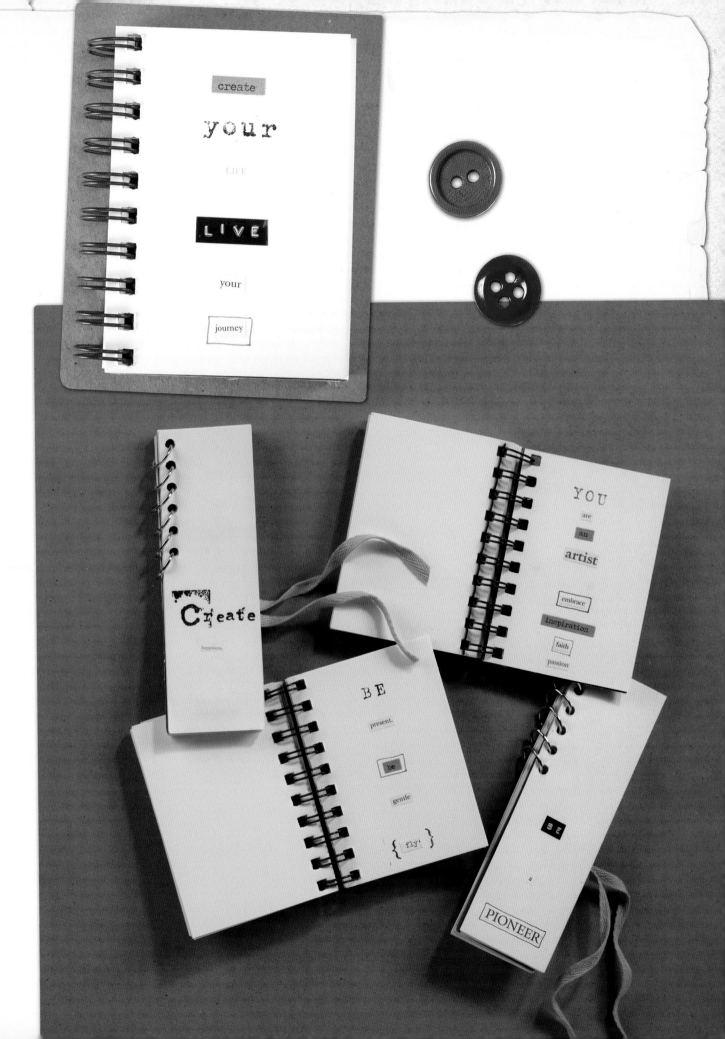

Altered Book

Creating an altered book while collecting your text and supplies for an upcoming journal project allows you to explore your creativity. Working on a project like this a little each day allows you to be creative on a daily basis outside of your main project.

I use altered books to inspire my journaling process, since old books take the pressure off of having blank pages. Here you can focus on finding your voice through written words on the pages. Find an old book at a used bookstore and work directly on the pages, emphasizing words or phrases with a black ink pen or oil pastels. If you have a theme for your journal, you can look for books that have a related subject matter. Some of my latest projects were created from books on planes, kites and birds.

Intention for this project:

Use your supplies to create a book that explores your journey through found poetry and small creative tasks.

MATERIALS LIST

a vintage book on a theme (such as birds or flight)

pens

label maker

oil pastels

glue stick

masking tape

rubber stamps (alphabet letters, images)

black ink pad

typed and printed journal pages

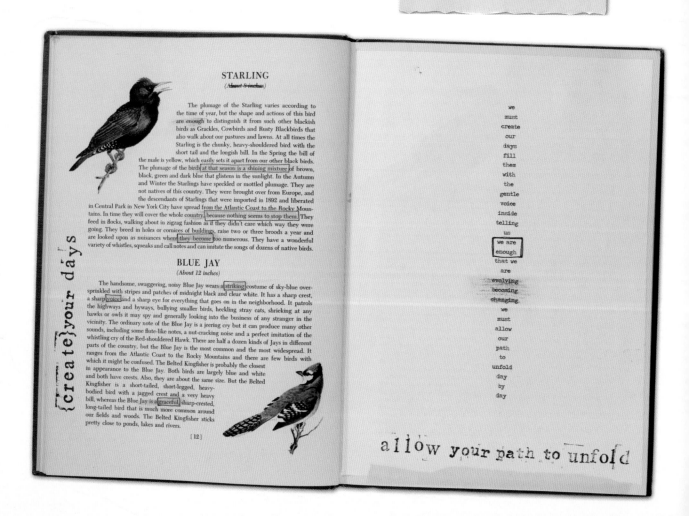

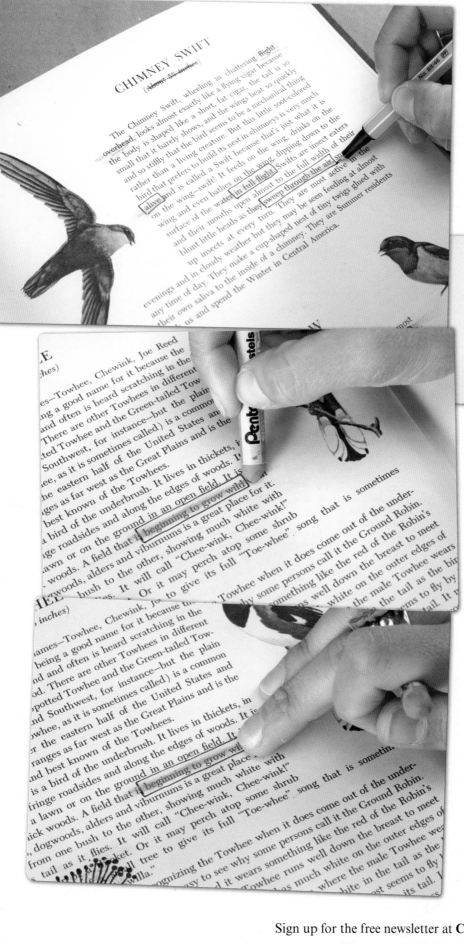

1 Set up your work area with the supplies you have collected.
 On a page of a book that you've chosen, find words or phrases that speak to you and box them in with a black pen. You can do one page at a time or go through the whole book to create a story.

TIP

Inspire your creative energy with music and a cup of coffee or tea.

2 Or use an oil pastel to draw a line of color over the word or phrase to highlight it.

3 Use your finger to smudge the color so the line isn't as crisp; this brings down the intensity and also allows the words to show through.

4 Create in the white space by placing a strip of masking tape with ripped edges on the page. Place a label with a meaningful phrase or word over the masking tape for a layered effect.

TIP

Masking tape works well to cover words you may not want to show. You can then stamp on top of the tape. Allow a few minutes for the ink to dry since the tape has a glossy texture.

5 You can cover text by placing a rubber stamp with black ink in a strategic place. Use an image that is meaningful to you or that follows your selected theme.

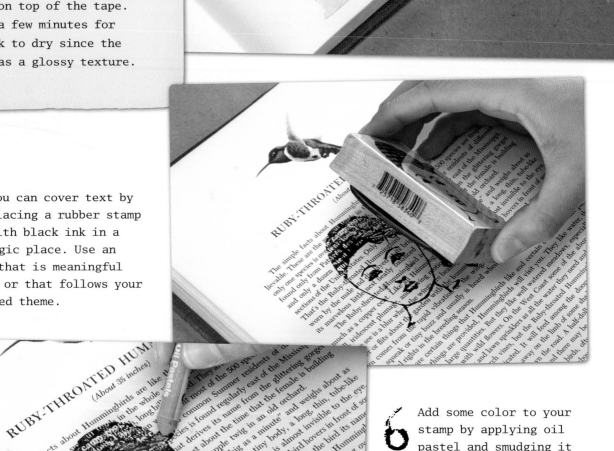

6 Add some color to your stamp by applying oil pastel and smudging it with your finger. Smudging also works to blend two or more colors.

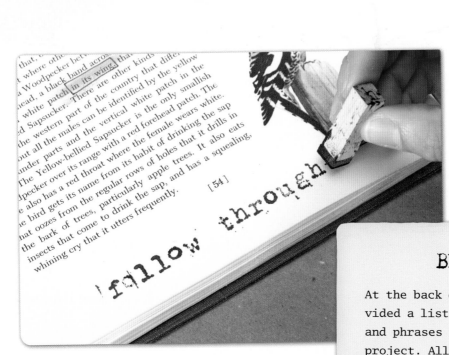

7 Add words that speak to you by using alphabet stamps. Stamp words or phrases in the white spaces. Use small, medium or large stamps depending on the amount of space you have or if you want to call attention to a particular word.

BE INSPIRED

At the back of the book I have provided a list of inspirational words and phrases that you can use for this project. Allow the words to speak to your heart.

8 Print a selection of your typed journal pages. Place the page over a page in your book and fold the paper to the same size as the book.

This is a great way to cover pages you don't like in the vintage book.

TIP

When selecting printer paper for your journal pages, select a heavier weight paper, but not as heavy as cardstock. This makes tearing the pages easier.

TIP

After you've printed a selection of your journal lists, organize them into the order you'd like them to appear in your altered book. This can help keep your space organized and guide you in exploring your theme for the book.

9 Tear your journal list down to size along the fold lines. The torn edge gives the paper a worn effect.

10 Glue your journal page to the book page using a glue stick. Press the pages together along the edges.

11 Emphasize your journal page by boxing in words or phrases with a pen, highlighting words with oil pastels or adding stamped words in the white space. Finally, tear a strip of masking tape in half lengthwise and add it to an edge of your journal page for added interest. You can also use masking tape to cover up stamping errors.

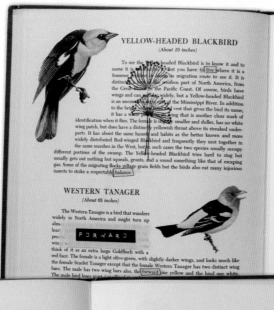

YELLOW-HEADED BLACKBIRD
(About 10 inches)

To see the Yellow-headed Blackbird is to know it and to name it is easy. But you have to live where it is a Summer resident or along its migration route to see it. It is distinctly a bird of the western part of North America, from the Great Plains to the Pacific Coast. Of course, birds have wings and can roam widely, but a Yellow-headed Blackbird is an uncommon sight east of the Mississippi River. In addition to the bright yellow head and vest that gives the bird its name, it has a white patch on each wing that is another clear mark of identification when it flies. The female is slightly smaller and duller, has no white wing patch, but does have a distinctly yellowish throat above its streaked underparts. It has about the same haunts and habits as the better known and more widely distributed Red-winged Blackbird and frequently they nest together in the same marshes in the West, but in such cases the two species usually occupy different portions of the swamp. The Yellow-headed Blackbird tries hard to sing but usually gets out nothing but squeals, grunts, and a sound something like that of escaping gas. Some of the migrating flocks pillage grain fields but the birds also eat many injurious insects to strike a respectable balance.

WESTERN TANAGER
(About 6½ inches)

The Western Tanager is a bird that wanders widely in North America and might turn up alm...
leas...
pea...
wan...

FORWARD

think of it as an extra large Goldfinch with a red face. The female is a light olive-green, with slightly darker wings, and looks much like the female Scarlet Tanager except that the female Western Tanager has two distinct wing bars. The male has two wing bars also, the forward one yellow and the hind one white. The male bird loses most...

you
will
find
me
at
the
water
camera
in
hand
toes
in the
tide
raising
my
hands
high
you will
find
me
collecting
rocks
at
the
harbor
capturing
my
dreams
as the
wind
blows

Sold with your dreams

i
am
learning
how
to
listen
to my inner
voice
to
process
my
thoughts
and
feelings
i
am
learning
how to
trust
the
unknown
i
am
learning
how to
speak
positive
and
to
{ live my }
vision

COMMON TERN
(From 13 to 16 inches)

Terns in flight over the ocean are certainly among the most beautiful and graceful birds in the world. They are often called Sea Swallows and it is a good name for them. They look like large black-capped white Swallows as they wheel and whirl in their ceaseless offshore patrol along our coast lines. They are, on the average, much smaller and thinner than Gulls and, as further marks of distinction, the Terns have more or less deeply forked tails and sharp pointed bills. Even at a distance Terns can be known from Gulls by their lighter and more dashing flight and by their habit of diving head-first into the ocean in pursuit of the small fish or other aquatic creatures they have discovered.

But Terns are like Gulls in one discouraging way. There are many species and some of them look so much alike that only the field experts can tell them apart on the wing. Where there are four species that so closely resemble one another in size and plumage as the Common Tern, Roseate Tern, Forster's Tern and Arctic Tern, an expert tells them apart...

TAKE FLIGHT

...so much alike in general appearance, even to the... beginner might... hope ever knowing one bird from the other, but there are small differences that are not difficult to note if the birds are seen regularly at close range. From a top view the primaries (large outer flight feathers of the wing) of the Common Tern are dark compared to the remainder of the wing and in the Forster's Tern the primaries are lighter than the remainder of the wing. Also, the upper surface of the tail of the Common Tern is white whereas it is gray for the Forster's Tern. Still, it does take time and patience to learn these things.

[60]

we are all beginning

PIED-BILLED GREBE
(From 12 to 15 inches)

Grebes are water birds that, from their size and general shape, might be mistaken for Ducks at a distance but they have pointed bills, sit much lower in the water than Ducks do and look as though they had no tails. Hunters often refer to them as "Hell-divers" because they dive so quickly and stay down so long. They have the ability to sink their bodies in the water and keep just their heads stuck up like periscopes. They do this when they are suspicious or frightened and wish to keep out of sight as much as possible. The Pied-billed Grebe is the smallest and most widespread of our common Grebes. It may be found as a Summer resident on almost any body of water, small or large, in North America. However, it prefers the smaller ones and it breeds regularly in our inland swamps and marshes and in the reeds surrounding our lakes and ponds. Seen on the water—and it is rarely seen out of the water—it is a small, dark, roundish bird with a somewhat snaky neck and head and a black band around it, the feature that gives the bird its name. Perhaps the only remarkable thing about the "Dabchick," as it is sometimes called, is its voice, a long loud call of "cow-cow-cow" repeated many times in the breeding season.

GREEN HERON
(From 16 to 22 inches)

In all of North America there is hardly a river, lake, marsh, swamp, pond, or water hole that isn't visited by a Green Heron at some time or other in warm weather. It is easily the best known, the most abundant and the most widespread of our Herons and has many different names given to it by farm boys. Its official name is the only confusing thing about this familiar bird. Why Green Heron? To most observers it shows more slate-blue or an even darker shade on most of its upper plumage. The crown is greenish-black and the feathers form something of a low raggedy crest at times. The neck is chestnut-reddish with a cream-colored streak running down the front and widening on the breast. When the Green Heron is flushed from its perch or from a feeding site in a bog it flaps away with a cry of "ske-ow!" if it makes any sound at all. Green Herons build crude nests in bushes or trees overhanging a pond, lake, marsh, or some other watery area. They eat the usual Heron diet and drift southward as soon as their Summer haunts are frozen over by cold weather.

[64]

believe & build your days

I
carry
bravery
i
carry
my
memories
and
camera
in hand
i
am
here
showing
up for
my
life for
my
days
I will
create
my
way
through
i
carry
27 years
and
a backpack
of
art supplies

we must go through——

{ honor }
the
process

it's
amazing
the
process
i
go
though
getting
ready
to
create
did
i
use
to
get
ready
?
need
book
photos
text
misc papers
misc supplies

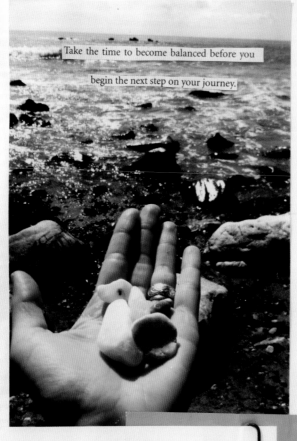

Take the time to become balanced before you

begin the next step on your journey.

Finally, obey the old rule that says don't forget your "ten essen-
tials." They are:

1. *Sunglasses* 6. *Flashlight.*
2. *Extra clothing (windbreaker,* 7. *First aid kit.*
rain gear, etc., as appropriate). 8. *Candle (fire starter).*
3. *Extra food and water.* 9. *Matches in waterproof container.*
4. *Maps.* 10. *Knife.*
5. *Compass.* 11. *Toilet Tissue, is usually added.*

Take a break. Go for a walk. Get out in the sunshine.

W39007A June Morn

Today I carry.... Wantin
to see my sis
to create art and get a
to go thrift store shop
get a tattoo
to evolve
to be fearless and bold
to love like I have nev
to cut out of magazines

— this reminds me of du
bins when we were kids

{4} The
Creative Collage Process

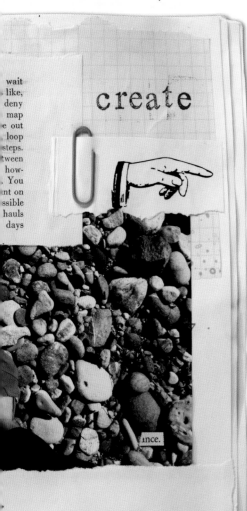

create

wait
like,
deny
map
e out
loop
steps.
ween
how-
. You
nt on
ssible
hauls
days

ince.

m the "real world"

—Brave & true

hurt

diving in the magazines

The creative collage process is a beautiful time that you can use to explore the art journaling journey you are on. This is my favorite part of the process. Up to this point we have explored our thoughts, visions and feelings through journaling. We have prepared for the creative process by collecting supplies and setting up our creative space. Now it is time to create and collage. The beauty in this process, as with the other processes in this book, is that there is no right or wrong way to go about it.

Over the years I have refined how I do things and I now have an order that makes this part fun. I will share my process for making visually meaningful collages and give you guidance along the way. I want you to know that you are not alone in this process and the feelings you may carry are the same or similar feelings I have when starting something new.

In this section we will walk together from the blank page to building the layers of a two-page spread. I will share the basic layout of a page, as well as different variations you can explore. During this time allow yourself to follow your inner creative artist, as well as to allow yourself to try new things.

The creative collage process is a means to discover your creativity. You are able to grow and evolve during this time. Together we will collage our days, our feelings and thoughts.

page by page,
create what you most need to find.

Beginning

When beginning the collage process, you may feel unsure about where to start. Even after completing quite a few art journals, I still struggle with beginning something new. The beauty of this book is that we are exploring this process together.

The creative collage process creates new opportunities and space to uncover and discover the creative artist inside of you. I believe we are all artists, even if we don't recognize it all the time. This is a chance to explore the artist in you through the collage process.

The collage process is similar to the journaling process for me; I enjoy taking time in the morning to create. Some mornings I will begin to look through my photos or supplies to see what catches my eye and then just lay them on the page. Take time to remind yourself that there is no rush to complete an entire page. It is important to be patient with yourself along the way. Simply taking time in the morning or the evening to sit at your work space is a step forward in this creative journey.

Over the years of creating my journals I have discovered that I have a steps I follow. I begin first by choosing one or two journal pages that I will use. From there, depending on the feeling of the text, I will match a photo that captures the theme I am exploring.

When I begin the initial layout of the page I do not use any glue. I take time to arrange different photos, text and papers on the page, working on a layout I like. This time is for exploring and having fun with supplies. I know for me that this first step of arranging things calms any nervousness I may have. I find comfort in knowing that nothing is permanent until I am ready to use glue.

There are times where I have glued things down and maybe found something I wanted to add or cover, and I will apply a new photo right on top of the photo I had originally glued down. There are always creative solutions of layering, covering or adding an item.

From there I will use the colors in the photo to create a color scheme. Collecting different papers, paint samples, buttons and so forth to add to the page becomes easier when a color palette has been established.

Having these steps helps simplify the process and allows me to explore my feelings. It provides some time to relax, create and breathe easy, even if it's just ten minutes in the morning.

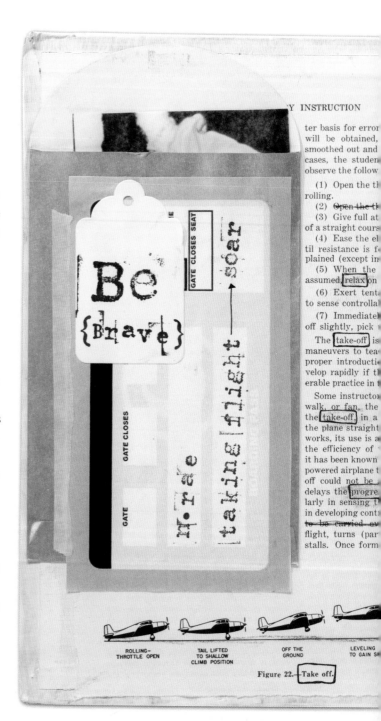

Visit **CreateMixedMedia.com/art-journal-art-journey** for bonus content.

In the next demonstrations, you will learn how a spread is created, and receive guidance along the way about the different design elements and ephemera you can add to your page.

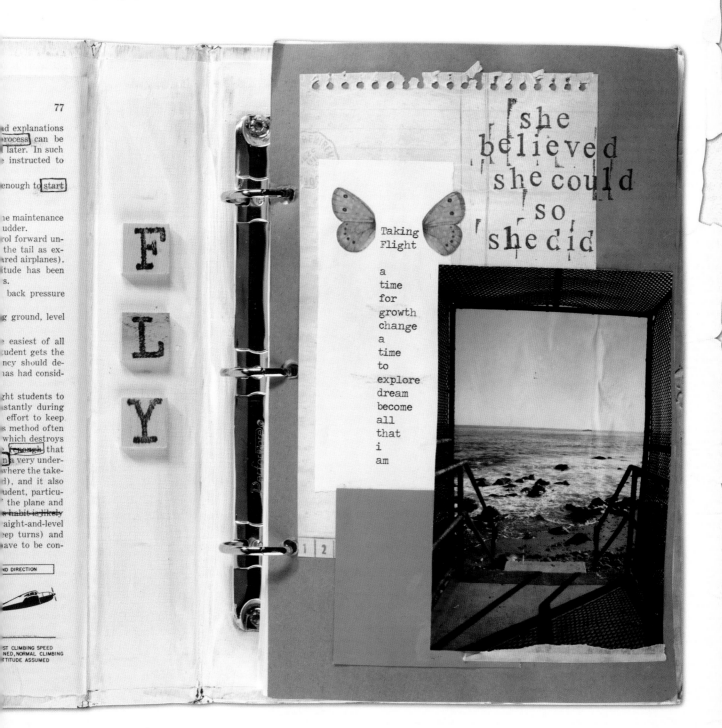

The Basic Layout

This demonstration shows you how to create the foundation for your page. The process always begins with the journal pages you have written, printed out and arranged in order of the story you want to share. Once they are organized, you are ready to start the first page in your journal. In the next steps, you will learn how to size down a journal page and then begin arranging various papers, photos and other elements to create a cohesive layout. I encourage you to take time to try different layouts before gluing them down. I have discovered over the years how to be patient with the process and how following these steps makes the collaging process simple and fun.

MATERIALS LIST

typed and printed journal pages

paint samples

photographs

old books

colored paper clips

vintage papers

glue

paintbrush

colored tags

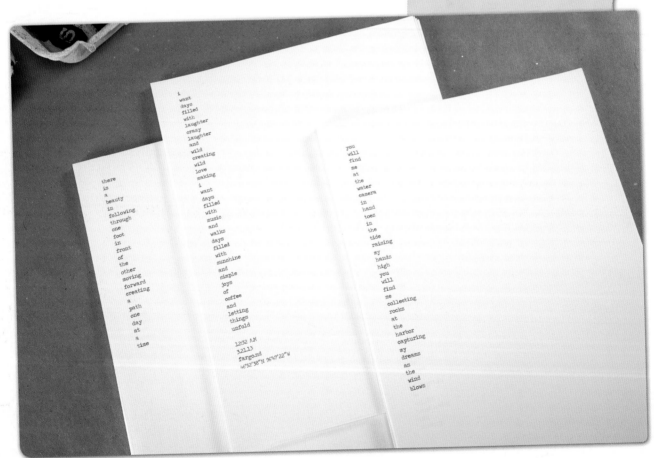

Build your foundation.

1 Print your journal pages and arrange them in a way that tells the story you want to tell. Create three piles that consist of the beginning, middle and end of the story.

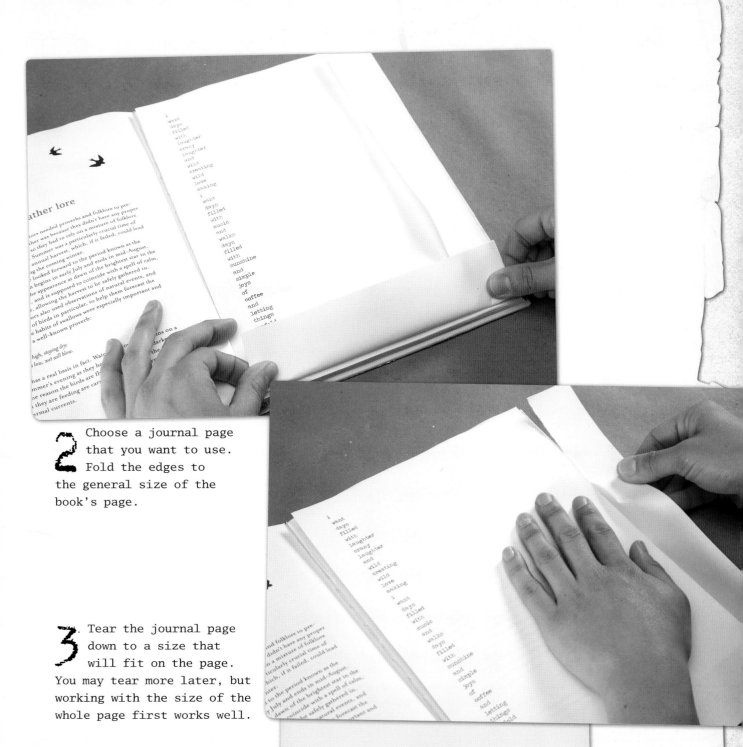

2 Choose a journal page that you want to use. Fold the edges to the general size of the book's page.

3 Tear the journal page down to a size that will fit on the page. You may tear more later, but working with the size of the whole page first works well.

TIP

When using vintage book pages, use the same folding and tearing process to fit the vintage page on your journal book's page.

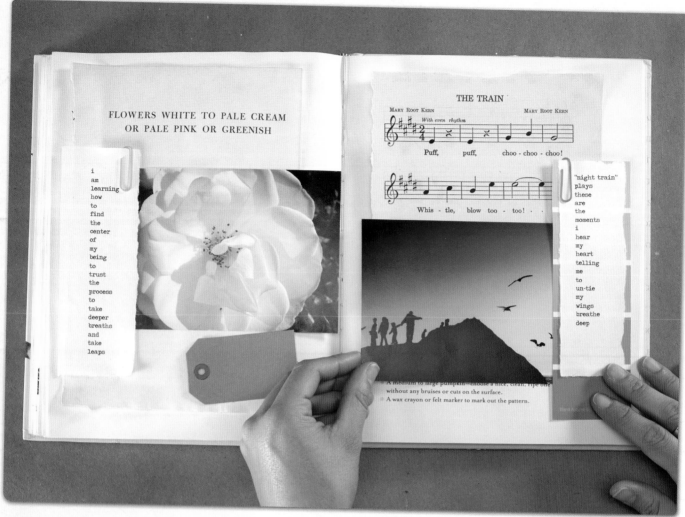

4 Once you have chosen your journal page, start looking through your photos and old books for paper and illustrations to go with the words. Use the colors in the photos to select little bits (tags, paint samples, etc.) that you can add to the page. Working on a two-page spread, start arranging elements in a visually meaningful way without adhering them.

In this case, the left page is already arranged in the layout I would like. The title on the vintage paper pairs with the chosen image, which was selected to complement the journal text. Unwanted text on the vintage page is covered up and the color of the tag matches a color element from the photo.

The next task is to arrange different elements on the right to connect the pages visually. My first arrangement is shown here: The journaling text I've chosen is about trains, so I've also chosen a vintage paper that says "The Train." I've also added a photo, but this one doesn't work for a couple of reasons: the horizontal image doesn't cover all of the book's original text at the bottom. It is also a photo by the ocean and doesn't relate to my journaling text about trains.

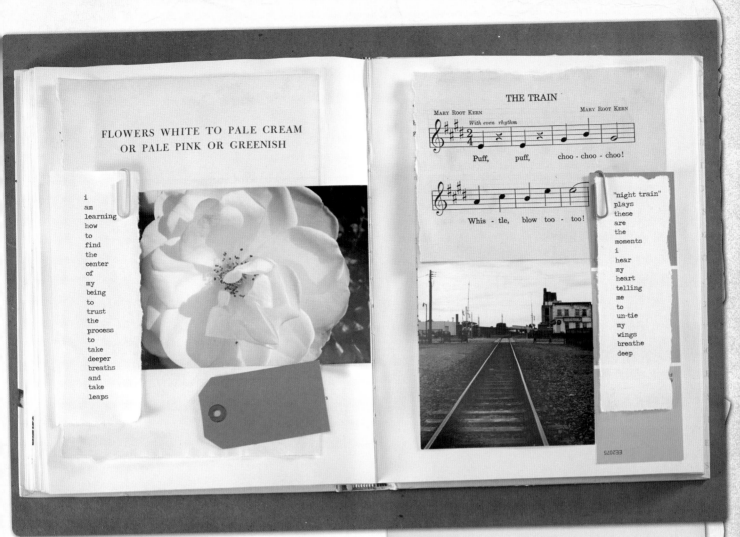

FLOWERS WHITE TO PALE CREAM
OR PALE PINK OR GREENISH

i
am
learning
how
to
find
the
center
of
my
being
to
trust
the
process
to
take
deeper
breaths
and
take
leaps

THE TRAIN

MARY ROOT KERN MARY ROOT KERN

With even rhythm

Puff, puff, choo - choo - choo!

Whis - tle, blow too - too!

"night train"
plays
these
are
the
moments
i
hear
my
heart
telling
me
to
un-tie
my
wings
breathe
deep

5 If your first arrangement didn't work, select a new photo or paint sample.
My second try has a vertical train photo that works with my chosen text. I've also tried featuring more of the vintage paper, but it covers up too much of the photo. The paint sample that is shown here contrasts with the other page's photo, so I will try a different color.

TIP

Working with a similar layout on each spread frees you to think more about the content of the story you are creating.

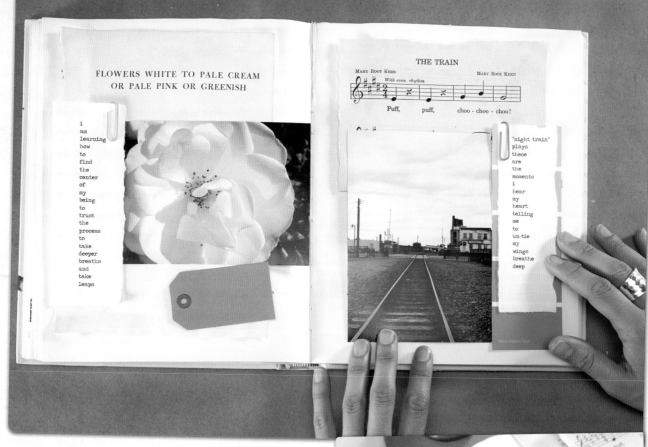

FLOWERS WHITE TO PALE CREAM
OR PALE PINK OR GREENISH

i
am
learning
how
to
find
the
center
of
my
being
to
trust
the
process
to
take
deeper
breaths
and
take
leaps

THE TRAIN

MARY ROOT KERN MARY ROOT KERN
With even rhythm

Puff, puff, choo - choo - choo!

"night train"
plays
these
are
the
moments
i
hear
my
heart
telling
me
to
un-tie
my
wings
breathe
deep

6 Rearrange your elements again if needed.

Once I have my collage and journal elements in a way that I like and that pairs well with the other page. The journaling text, vintage paper and photo all speak to the theme of trains. The paint sample picks up colors from both the train photo and the flower photo on the left, and the image isn't hidden by the vintage paper. Now I'm ready to make the arrangement permanent.

7 Using a paintbrush dipped in white glue, paint a thin layer of glue on the book's page or the bottom layer of your layout. Adhere the first paper to the book page.

When you're ready to add your photo, carefully pull apart the image from the backing. Paint a thin layer of glue onto the back of the thinner photo. Removing the back makes the paper crinkly after the glue dries, giving it character. If the picture curls at the edges, apply a bit more glue.

TIP

Photos, paint samples and post-cards are usually made from thick paper that can be separated front from back. This allows the element to bend to the shape and warping of the pages in your book when you glue it down.

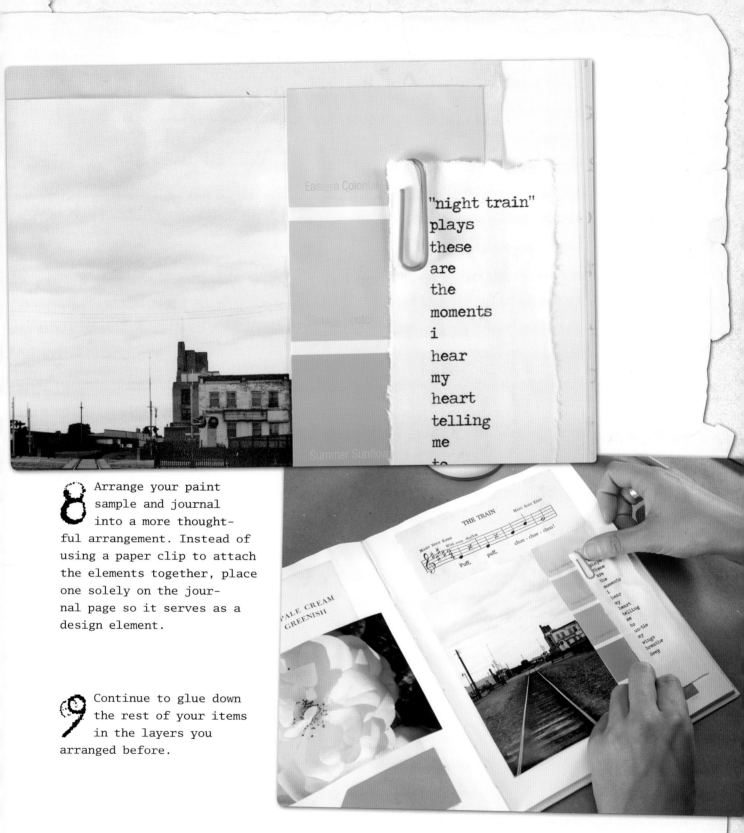

"night train"
plays
these
are
the
moments
i
hear
my
heart
telling
me
to

8 Arrange your paint sample and journal into a more thoughtful arrangement. Instead of using a paper clip to attach the elements together, place one solely on the journal page so it serves as a design element.

9 Continue to glue down the rest of your items in the layers you arranged before.

Variation: Vintage Book Pages

To create additional layers on a spread, you can use pages from old books you have. Look for old sheet music or even dictionary or thesaurus pages and highlight or box in words you like from that page. I also like using the "Table of Contents" and "Index" pages of books to add in the beginning and ending of my books. I look for old books that may have vintage paper I can use to add character to the page. There are a variety of ways to use these pages. If you like the text on the page you can create a page around that, or you can cover up the text and use the edges for a border to frame a photo.

MATERIALS LIST

vintage papers

journal

scissors

paper clips

photographs

paint samples

glue

paintbrush

1 On the left page, the original text and illustration from the book I'm using as a journal takes up a large portion of the page. To cover it, I cut out a large blank page from the front of another used book and glued it in as a background layer.

You can also use old book pages with deliberately chosen text. On the left side of the spread, the words "Map and Compass" create a message for this spread. On the right side, the words of the music add to the message.

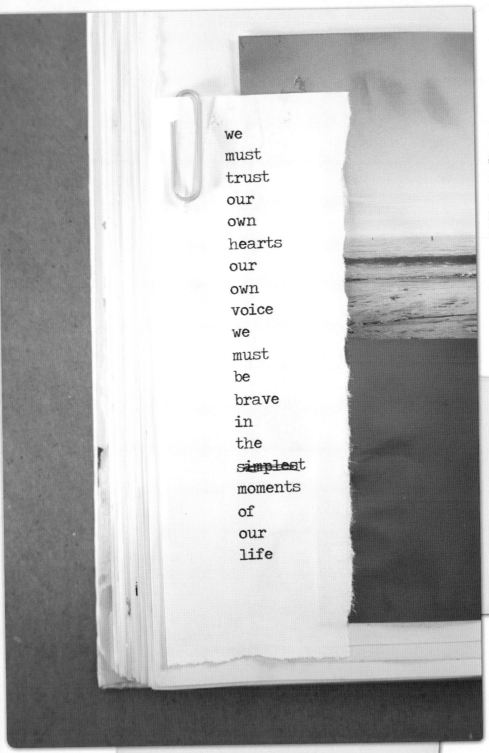

we
must
trust
our
own
hearts
our
own
voice
we
must
be
brave
in
the
~~simplest~~
moments
of
our
life

2 Cover up any words you do not want (in this case the publication information or lyrics of the song) with a paint sample, photo and journal text as a layered collage element.

TIP

Find old books at library book sales, garage sales or thrift shops.

TIP

If you find journal text you no longer connect with, use a black pen to scratch out those words.

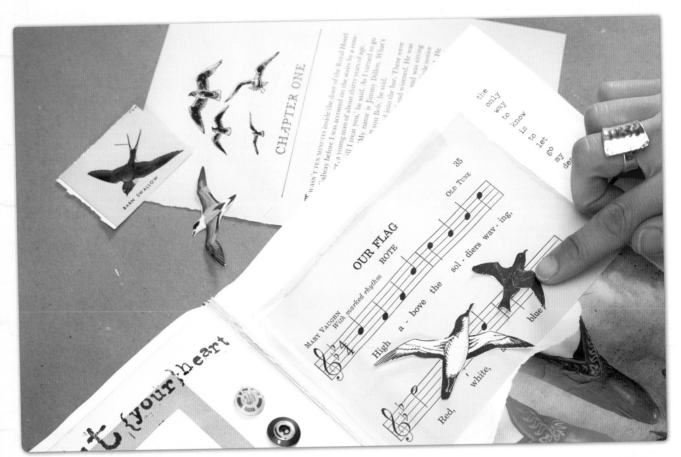

3. Find design elements or illustrations in old books that can be cut out and adhered to the pages either as an enhancement to the message or to cover any text you don't want showing.

DESIGN EXPLAINED

For this page, I started with the photo of the cowboy boots with red leaves and I decided it would be the main color palette. The colors felt patriotic to me so I paired them with an old music page titled "Our Flag." The yellow accent color was pulled from the color in the details of the boot design. I chose to add just one color accent with oil pastels (the yellow). I enjoy the simple feel of this page.

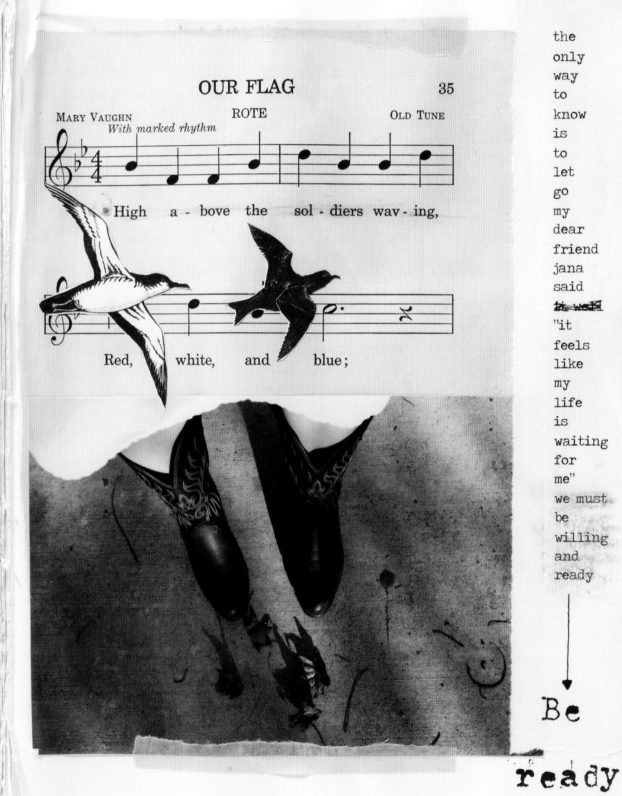

the
only
way
to
know
is
to
let
go
my
dear
friend
jana
said
~~it was~~
"it
feels
like
my
life
is
waiting
for
me"
we must
be
willing
and
ready

Be

ready

Variation: Hiding Straight Edges

When working with papers and photos in your journal, you'll find that quite a few straight edges and 90° corners created are by these elements. You can soften these edges by applying masking tape or little bits such as a fortune from a fortune cookie. Decorative washi tape can add both color and pattern to the page. These elements also have power to tie the page together and create a more cohesive feel.

MATERIALS LIST

journal

buttons

paper clips

tag

photographs

lined paper

glue

paintbrush

masking tape

paper ephemera

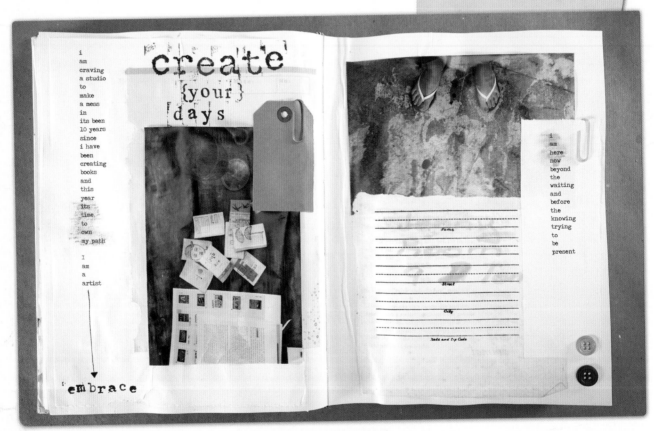

1 Create a journal spread on a theme that speaks to you using the basic techniques shown previously.

Sometimes the straight, crisp edges of a photograph or journal page don't fit with the aesthetic of a theme, as in this spread. The spread could be considered complete, but it has a lot of straight edges that I want to cover to create a softer feel.

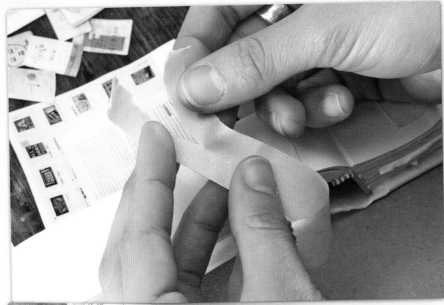

2 Cut a piece of masking tape that is slightly shorter than the length of your photo edge or journal page edge. Then tear the tape in half lengthwise to create a rough edge.

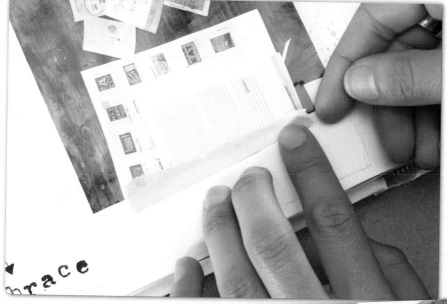

3 Cover the straight edge of the photo with the torn masking tape.

4 To eliminate the sharp 90° meeting of the journal page/photo/vintage page and to add an additional design element, glue a fortune from a fortune cookie onto a torn scrap of paper then glue it to the right page.

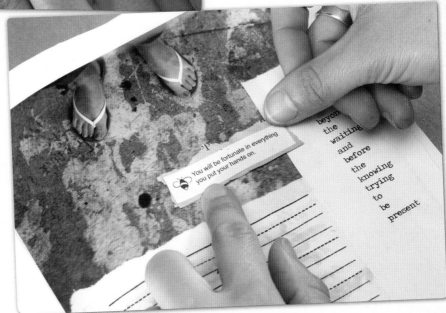

i
am
craving
a studio
to
make
a mess
in
its been
10 years
since
i have
been
creating
books
and
this
year
its
time
to
own
my path

I
am
a
artist

create
{your}
days

embrace

Visit **CreateMixedMedia.com/art-journal-art-journey** for bonus content.

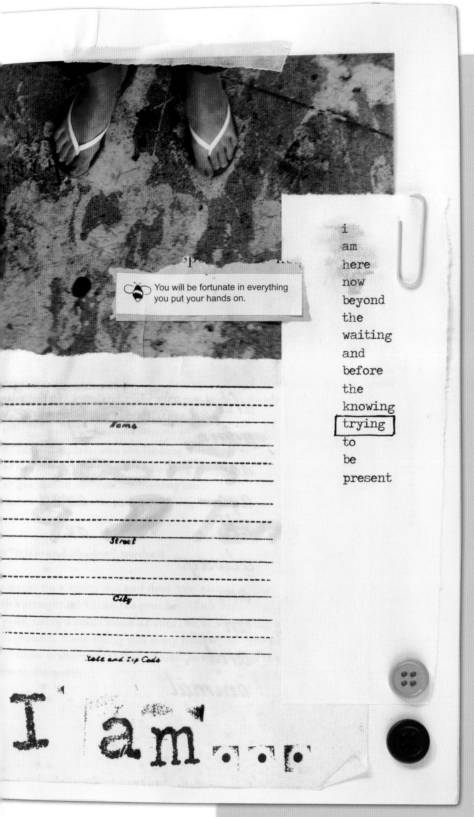

DESIGN EXPLAINED

For this spread I used color to tie the two pages together. I started with the photo on the left, choosing the blue color to add to the right page with the image and buttons. I added an olive green tag on the left page to bring out some of the green color in the image with the art supplies. The lined paper on the right page already had some yellow markings on it. To tie this color in on the left page, I chose to add the paper with the yellow strip along the top behind the photo. Once you have repeated the color, your eye will begin to travel around the page linking those colors together thereby creating a visual story. Create these pages any way you would like.

Variation: Vintage Postcards

Postcards can add a travel or adventurous feel to your journal page. Use the front of the card for the graphic elements or flip it over to show the blank message box to add space for stamping/journaling. You can find vintage postcards at thrift stores, antique shops and used bookstores.

Create your own path.

MATERIALS LIST

journal

postcards

paint samples

photographs

paper clips

glue

paintbrush

buttons

scissors

stamps and ink pad

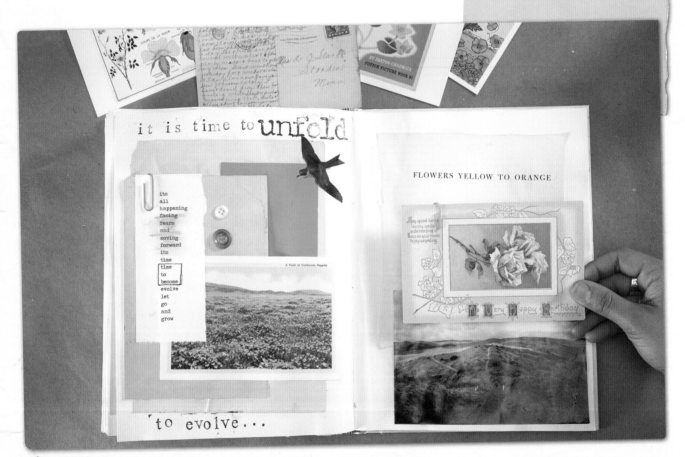

1 The left page, which is complete, uses colors pulled from the postcard image to create the color palette.
I wanted the right side to also feature a postcard to tie the pages together. This postcard image has green but the image doesn't connect with the theme of this page. The flower doesn't work with the text on the vintage paper on the page, either.

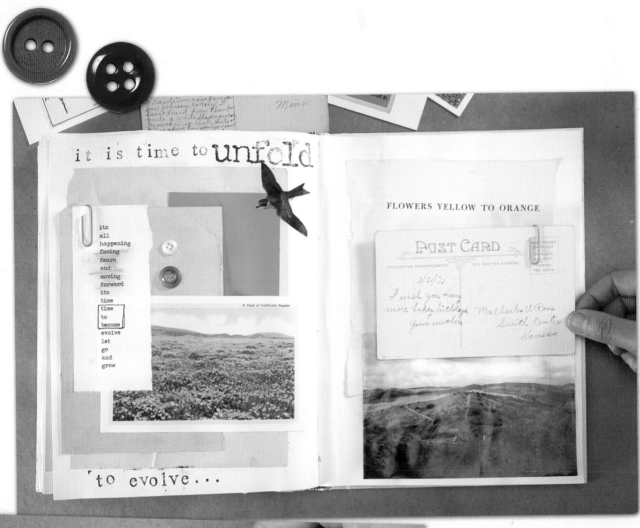

2 I flipped the postcard over to show an interesting font, the personalized element of the handwriting and a hint of green that matches the left page of the spread.

3 After placing the postcard I saw the large white area along the top. As you did with the mini projects, you can cut individual words from your journal pages and glue them across the top.

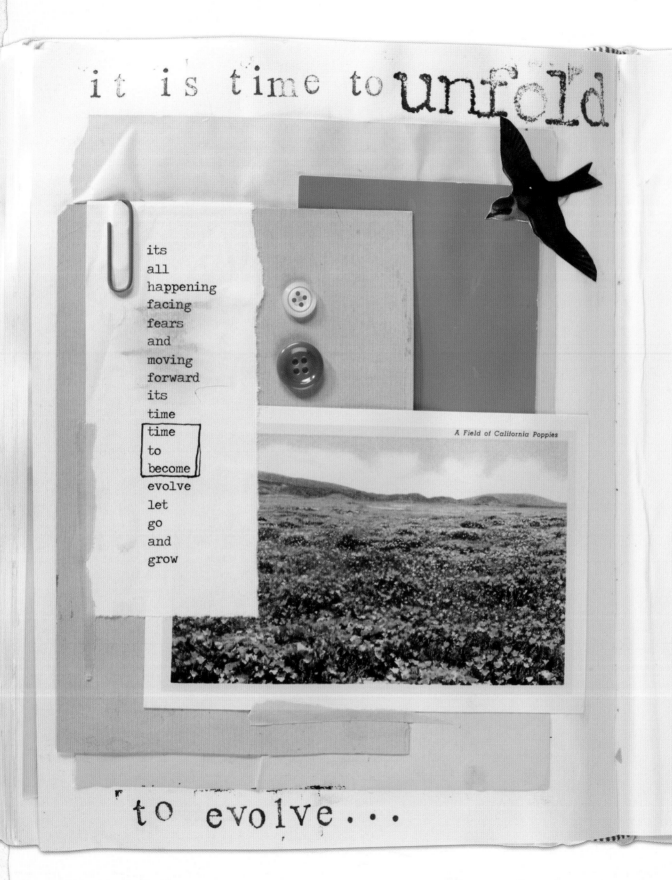

it is time to **unfold**

its
all
happening
facing
fears
and
moving
forward
its
time
**time
to
become**
evolve
let
go
and
grow

A Field of California Poppies

to evolve...

Visit **CreateMixedMedia.com/art-journal-art-journey** for bonus content.

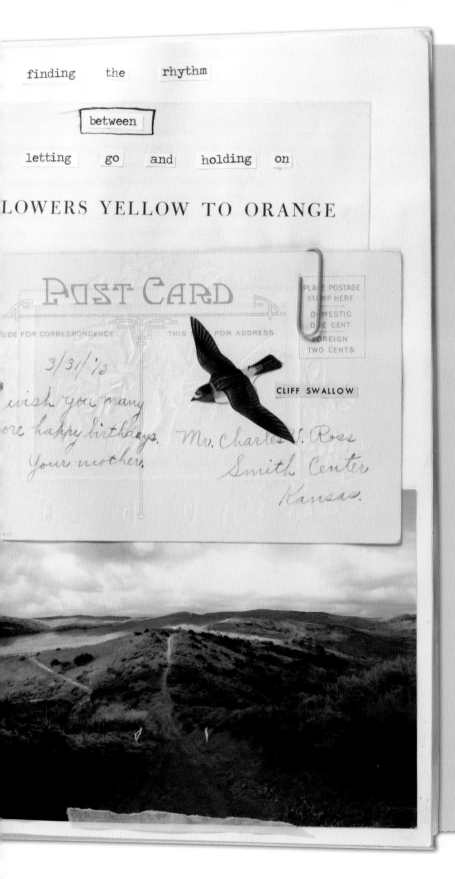

finding the rhythm

between

letting go and holding on

LOWERS YELLOW TO ORANGE

DESIGN EXPLAINED

For these pages I used both images and color to tie them together. I started with a vintage postcard with a field of poppies on it and wanted to use an image I had captured of an open field in California on the other side. I found an image that had lots of green in it that I could tie in with the green in the field. This became one of the main colors for these pages, so I also found a light green book cover page to include behind the postcard. I chose to bring in the orange and blue as well in the paint sample and paper clips. By peeling apart the postcard, I was able to use the back of the poppy field postcard on the right side. This allows the eye to tie these together and also adds meaning to the words "It is time to unfold." You can use color, images or words, and repeat it on the opposite page to connect the two pages together. There is freedom in what design elements you can repeat and you can let your theme guide you.

Highlighting Words

I have always had a love for words and that's why I love using them in my art journals. The use of positive words and phrases is part of the self-growth process that I embark on when journaling. I find that bringing emphasis to certain words or phrases helps me explore my thoughts and guides me through the process of sharing my story. In this demonstration, you'll highlight text from your journal pages (or other words from found book pages) using oil pastels or a black pen to box in a word or series of words.

MATERIALS LIST

journal

photographs

paper clips

vintage paper

stamps

glue

paintbrush

oil pastels

fine-tip black ink pen

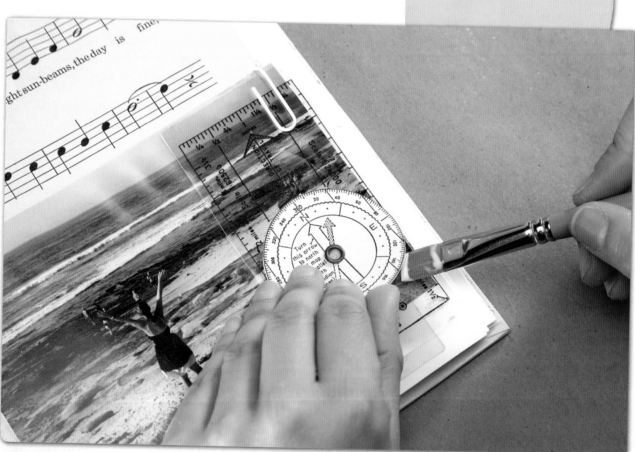

1 Create a basic spread on a theme that speaks to you. Glue down your paper, photograph and journal page.

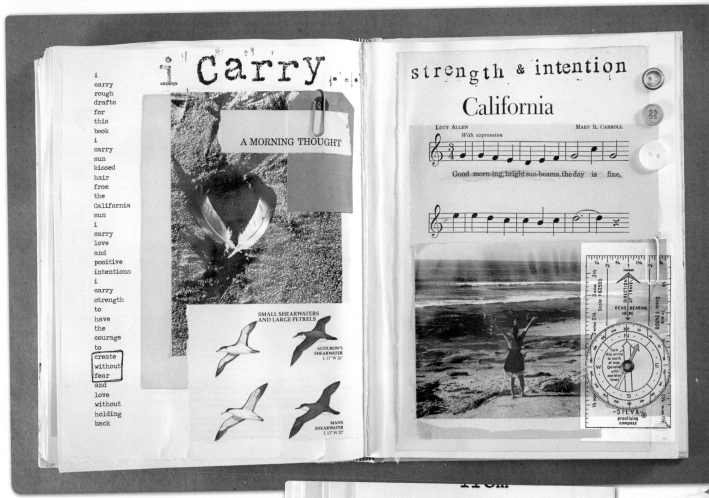

2 These pages could be considered complete as is, but I would like to add a few more design elements. I would also like to focus more on the words in the journal page.

3. Highlight selected words with an oil pastel or use a black ink pen to draw a box around words or phrases that emphasize the message of the story on your spread.

In this case I used a pastel to highlight the phrase "i carry love and positive intentions" because the theme of this page is "I Carry."

from the California sun i carry love and positive intentions i carry

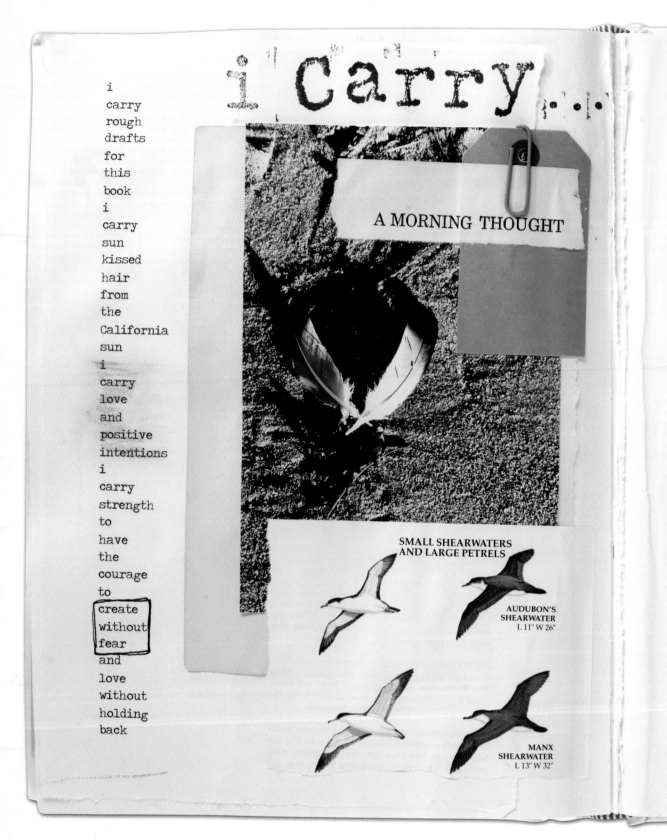

i
carry
rough
drafts
for
this
book
i
carry
sun
kissed
hair
from
the
California
sun
i
carry
love
and
positive
intentions
i
carry
strength
to
have
the
courage
to
create
without
fear
and
love
without
holding
back

A MORNING THOUGHT

SMALL SHEARWATERS
AND LARGE PETRELS

AUDUBON'S
SHEARWATER
L 11" W 26"

MANX
SHEARWATER
L 13" W 32"

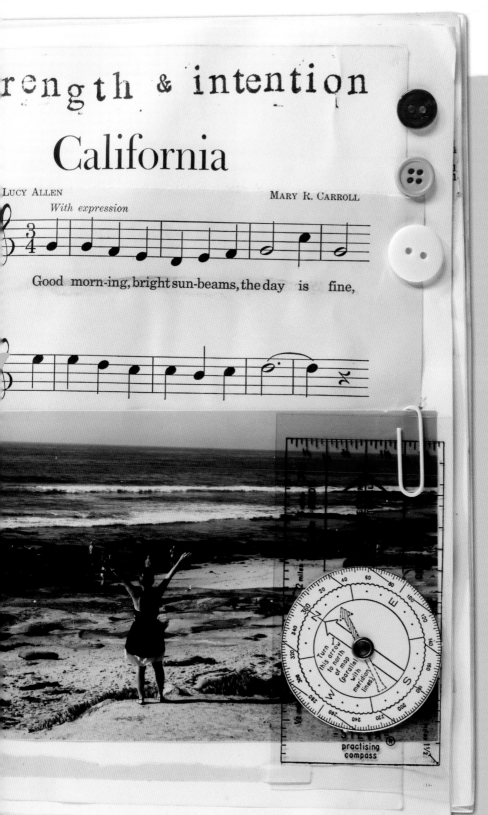

DESIGN EXPLAINED

I used an olive green pastel to complement the green tag and the green in the photograph on the opposite page. This little touch of color connects the two pages so that they become one cohesive story.

Using Rubber Stamps

One of my favorite steps in finishing a journal page is adding text with rubber stamps. A variety of fonts and sizes of alphabet rubber stamps can be had, which is why they are one of my favorite supplies. When laying out a journal page I intentionally leave open spaces on the page so I can add stamped text to the page. I create these open spaces by using blank book pages or paper in the basic layout.

Knowing that you can fill your journal page with blank pages provides a creative solution for not having every inch of the page covered. Stamp the words you want to emphasize on the page.

MATERIALS LIST

journal

vintage paper

photographs

paint samples

lined paper

glue

paintbrush

paper clips

tags

alphabet rubber stamps

black ink pad

buttons

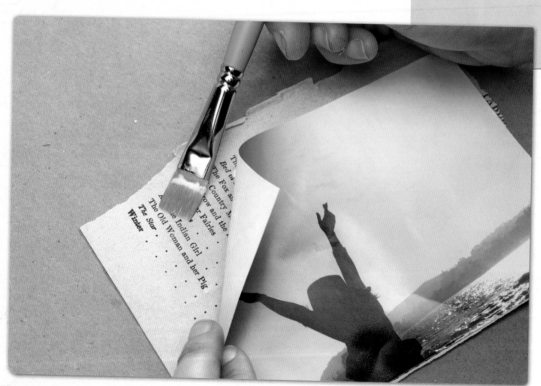

1 Create a basic journal spread with layered vintage papers, photographs and other "little bits" that you choose.

Glue a photo to a browned vintage book page to add a bit of contrast if your photo's color matches the paint sample too closely. The brown paper behind the photograph makes the image stand out more.

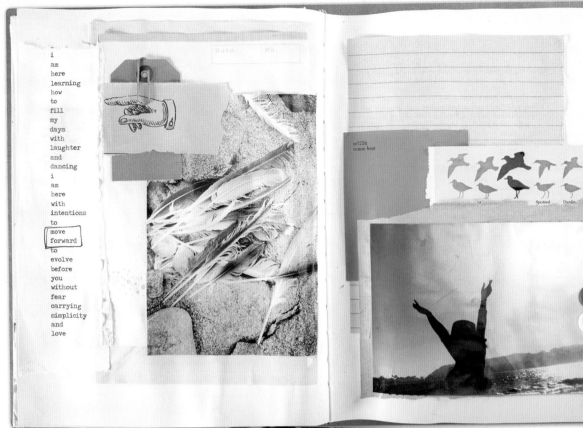

2 Wide-lined paper that is used to teach children how to write their letters makes for a great space to add words or phrases to your journal. I used the lined paper in the top right of this page to create an open space to stamp words.

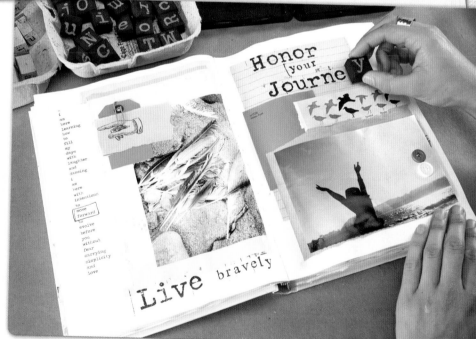

3. Use rubber stamps with black ink to fill areas of white space with words or phrases that speak to you. You can also use different sizes of the stamps to emphasize meaningful words.

i
am
here
learning
how
to
fill
my
days
with
laughter
and
dancing
i
am
here
with
intentions
to
move
forward
to
evolve
before
you
without
fear
carrying
simplicity
and
love

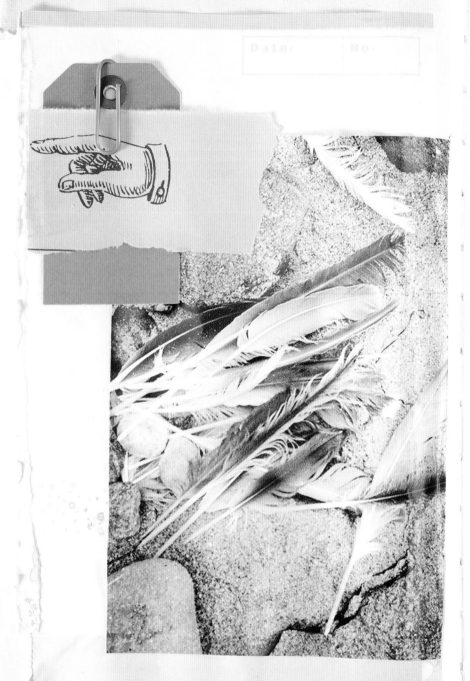

ar1226
ocean front

Live bravely

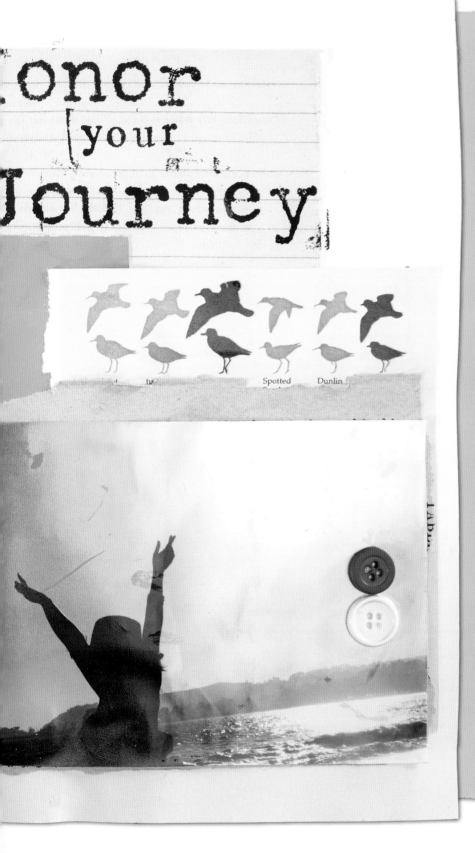

DESIGN EXPLAINED

When looking at these pages, you'll see that I used color as the main element to connect the two pages together. I started with the photograph on the right and pulled the blue color from that, then added blue "little bits" (paper clip, oil pastel, paint sample and bird illustration) to the left side. I also wanted to add some neutral beach tones to the page. I found the photo of the feathers on the sand and used the caramel brown color to tie into the right page with buttons and paper backgrounds. I added a little green onto the page with the paper tag, I felt it needed one more color.

Little Bits

This part of the collage process carries a lot of creative freedom. Once you have placed your papers, journals and photos into place it is time to add the "little bits" to the page. These are fun elements that lend color and movement. Some of my favorite bits are paper clips and buttons. Paper clips can be used as decorative elements as well as functional elements that hold fortunes, stamps, tags and small illustrations or images.

There are all kinds of little bits to add to your page. Explore the scrapbook section of your local craft store and browse old books for images or illustrations. You can also include your own drawings or papers you have collected.

MATERIALS LIST

journal

vintage papers

glue

paintbrush

paint samples

paper ephemera

buttons

paper clips

1 Paper clips are a great way to add a pop of color to a flat page. These pages could be considered finished as is, with bits of tape, vintage sheet music and a photo to match the journal page.

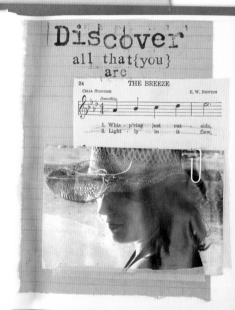

2 You can use buttons or paper clips to add variety to your pages.
 Attach the paper clip to the photo before gluing the photo down. Slide a found illustration or paper under the paper clip. Including paperclips in your initial spread allows for the opportunity to slide more little bits in later.

3. Select buttons of two or three different colors and different sizes that match the color scheme of the page and glue them to a blank space. Put the smaller one on top so the "heavier" button is under the smaller.

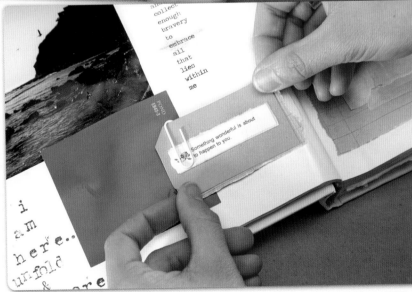

4. Paper clips also can be used to layer two or three collage elements together. Layer graduated sizes of vintage paper, colored tags, fortunes, stamps or other found elements and clip them together with a matching or complementary paper clip. If you need to, glue these layered bits together before clipping them.

5. Glue these collaged elements to your page in an open area or places where you'd like to cover unwanted text.

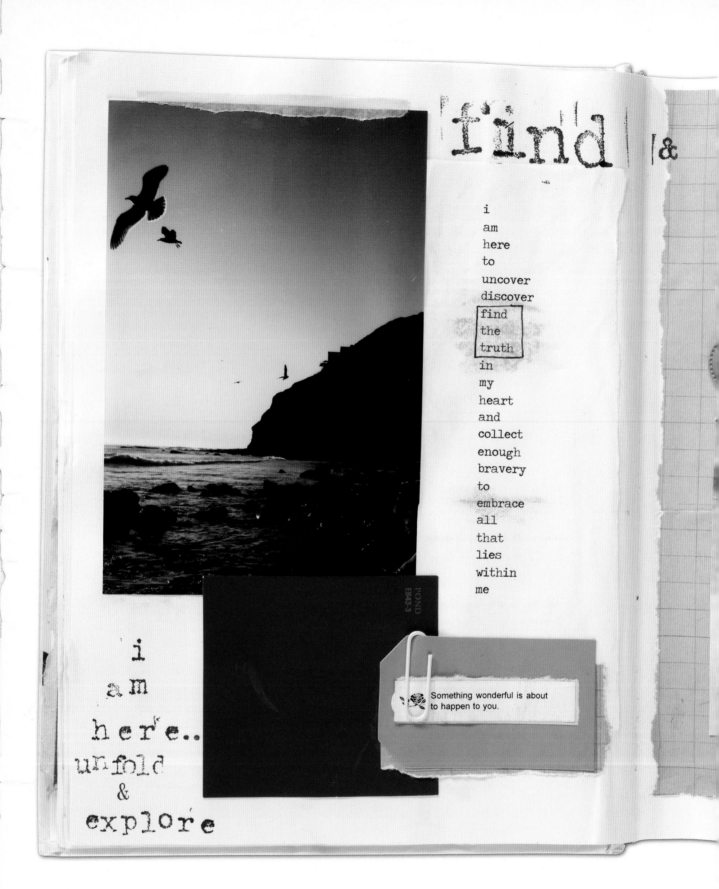

find &

i
am
here
to
uncover
discover
find
the
truth
in
my
heart
and
collect
enough
bravery
to
embrace
all
that
lies
within
me

POND
EB43-3

Something wonderful is about
to happen to you.

i
am
here...
unfold
&
explore

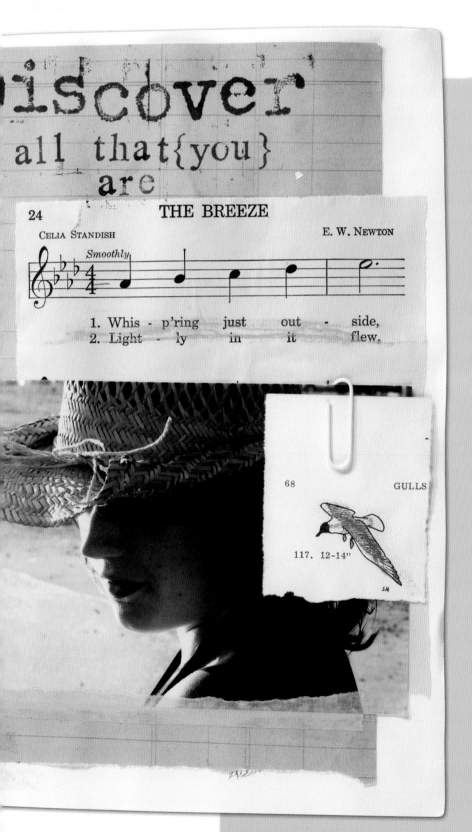

DESIGN EXPLAINED

For these pages I chose to use color as the main focus. Two of my favorite colors—I call them my life colors because they show up in my art and home so frequently—are teal and golden yellow. First, I found the image on the left side of the harbor in Dana Point, California. Because it has that beautiful teal color with accents of yellow, I did not want to add any more colors, so I chose to use a black-and-white image on the right side. I used vintage notebook paper in the back to bring warmth to the page and to soften the black and white. Then I added both paint samples, a paper tag, paper clips and buttons to tie the two pages together.

Inside Front Cover

The inside front cover is a great space to use for exploring the theme you have chosen for your book. On these two pages I used images and words that introduce the theme of my journal: my journey while living in California. I often use maps to set the location of my theme as well as a journal page of text that introduces the story I will be sharing. I sometimes attach envelopes to be able to include some sentimental items or papers with words I want to have as part of the book. Remember that every person's journey is different, and art journaling is a creative way to explore your path.

MATERIALS LIST

photographs

map

paper clips

washi tape

journal

glue

paintbrush

paper ephemera

oil pastels

decorative envelope

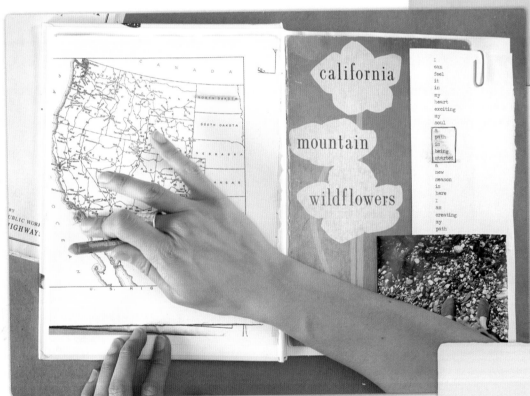

1 Create a two-page journal spread using photos, journal pages and other ephemera that speak to the theme of your journal.

Keeping my theme in mind, I created the right side of this spread using a vintage book cover about California along with a photo and journal page that fits well.

To match the left side to the right, I've glued a portion of a vintage map and highlighted with a pastel the places that are meaningful to my journey, such as California.

TIP

If you find a map that you like, make photocopies of it so you can use it more than once. Just remember to consider copyright laws and the final intended use of your journal before doing so.

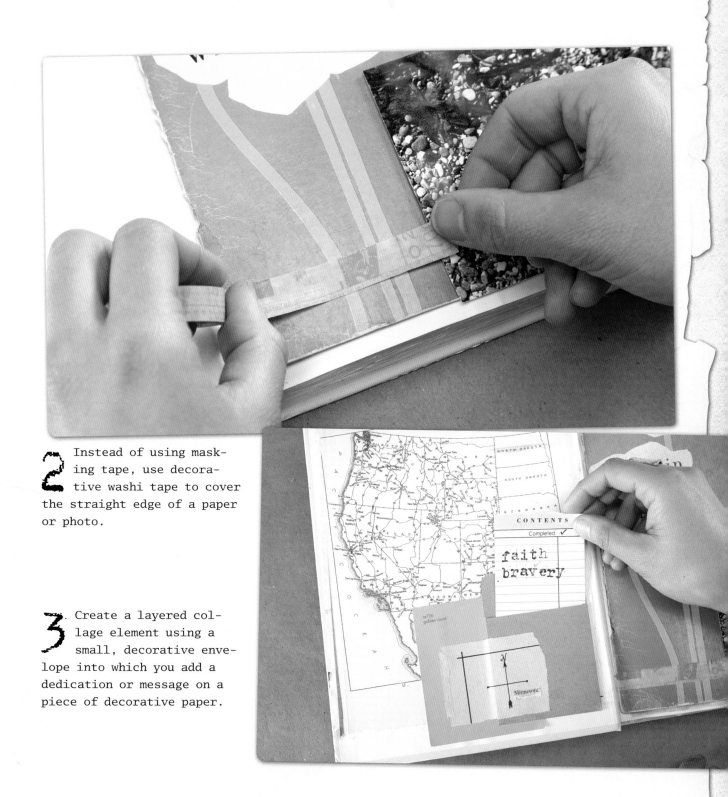

2. Instead of using masking tape, use decorative washi tape to cover the straight edge of a paper or photo.

3. Create a layered collage element using a small, decorative envelope into which you add a dedication or message on a piece of decorative paper.

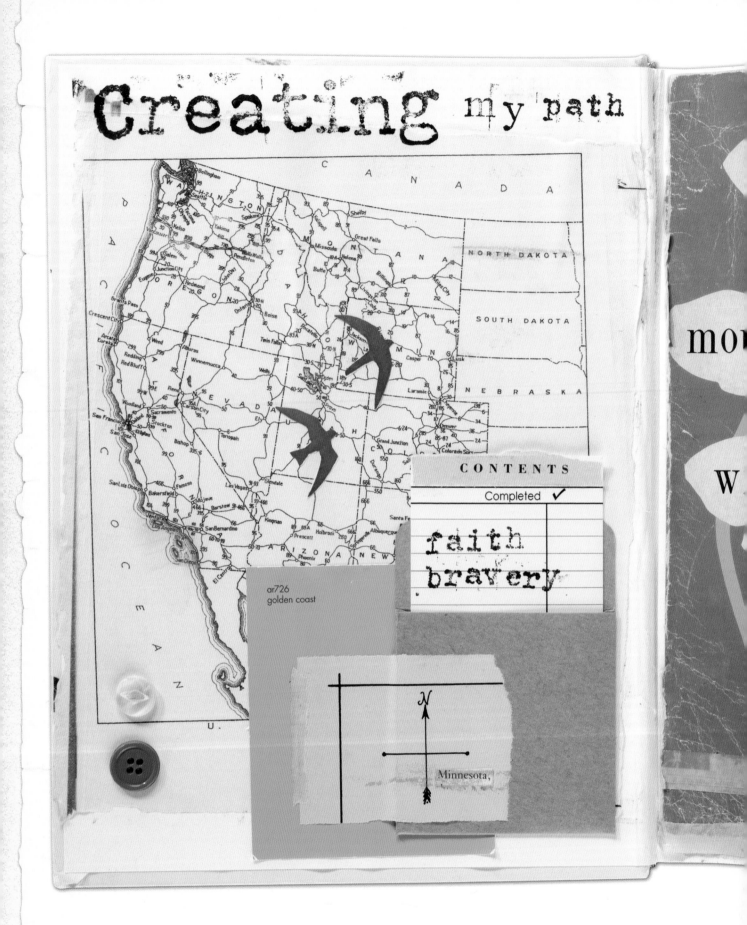

creating my path

CONTENTS

Completed ✓

faith

bravery

ar726
golden coast

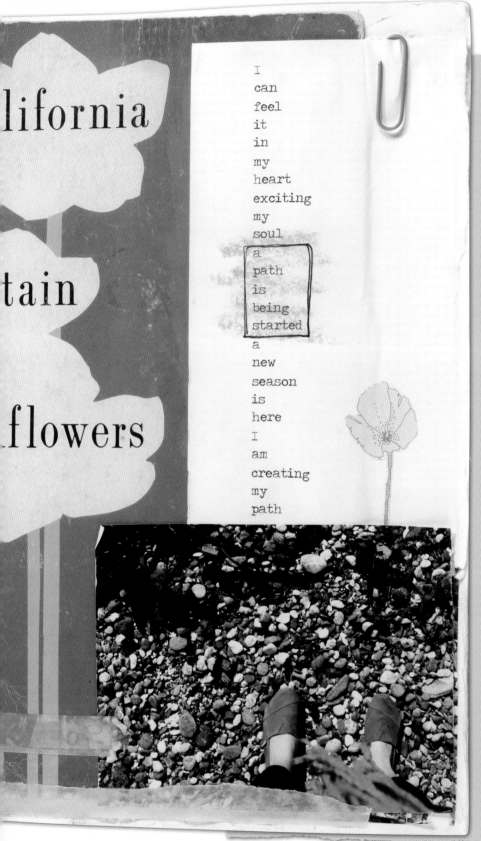

lifornia

tain

flowers

I
can
feel
it
in
my
heart
exciting
my
soul
a
path
is
being
started
a
new
season
is
here
I
am
creating
my
path

DESIGN EXPLAINED

In these pages I have tied the colors from the vintage book cover into the photo I chose. Since there was quite a bit of color in the book image on the right, I wanted to add only accent colors on the left side. The map is important to me so I chose to highlight the locations I would be exploring. The paint sample is not only one of my favorite colors, but the name of the paint, Golden Coast, also fits in nicely with this page.

Inside Back Cover

Similar to the inside front cover, I use the last page and inside back cover to bring closure to the journal as well as create a beginning for the next journal. I also summarize the theme of the book and add the location where the journal was made using rubber stamps or little bits. On these final pages, I always include an envelope where I can keep items that I either forgot to include on a page or bits that won't hold up to being glued on a page, such as feathers or leaves. The envelope also works well to keep larger pieces of paper that you don't want to tear, but won't fit on the page as is. Simply fold them and put them inside an envelope. Choose your envelope based on the size of the items you want to include.

MATERIALS LIST

journal

postcards

photographs

ephemera

scissors

envelope

pen

stamps and ink

small letter tiles

glue

paintbrush

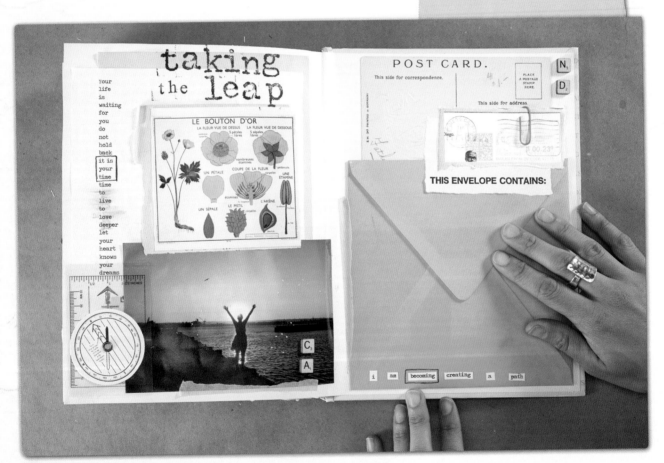

1 Create and collage the last page and inside back cover using the techniques you've learned in the previous pages.

Select an envelope to hold meaningful ephemera. Glue the envelope to the inside back cover using white glue and a paintbrush.

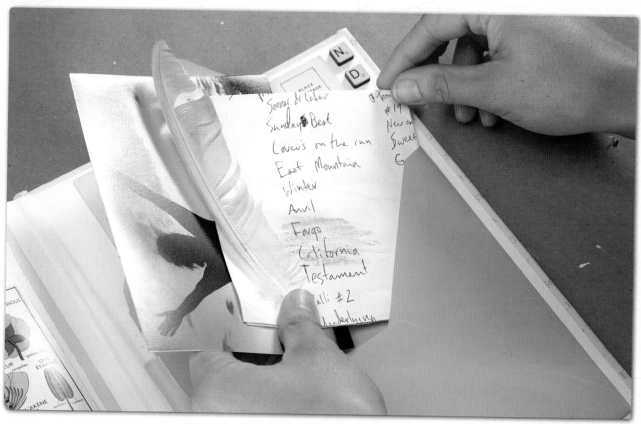

2 Use the envelope to hold all of your sentimental papers and photographs. If you find something along the way, such as this feather, you can keep it in the envelope.

3 Seal the envelope if you'd like your ephemera to stay enclosed, or use masking tape for a temporary closure.

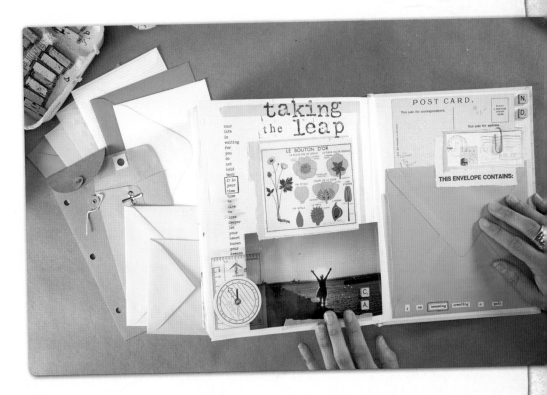

The Cover

The cover of the book is always created after I have completed all of the pages. I enjoy taking the creative journey of writing and collaging to explore possible titles for the journal. As I collage, I will set aside some of my favorite photographs to consider for the cover. The cover consists of a photograph and only a few extra "little bits."

If you choose to use three-dimensional elements such as buttons, paper clips, etc., make note to use a glue that will bond the items firmly to the cover. Use rubber stamps to write the title both on the front cover and the spine of the book.

MATERIALS LIST

journal

stamps and ink

photographs

vintage papers

scissors

glue

paintbrush

1 Use the same layering techniques you used for the inside pages to adhere papers and photos to the front cover. On the front cover, make sure the edges of each layered item are securely glued down so they do not lift up when you travel with your book.

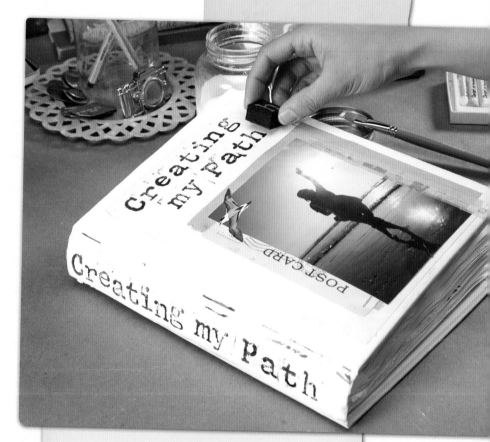

TIP

If you choose to use a photo, you don't need to peel off the back because the front cover won't warp the same way the pages do.

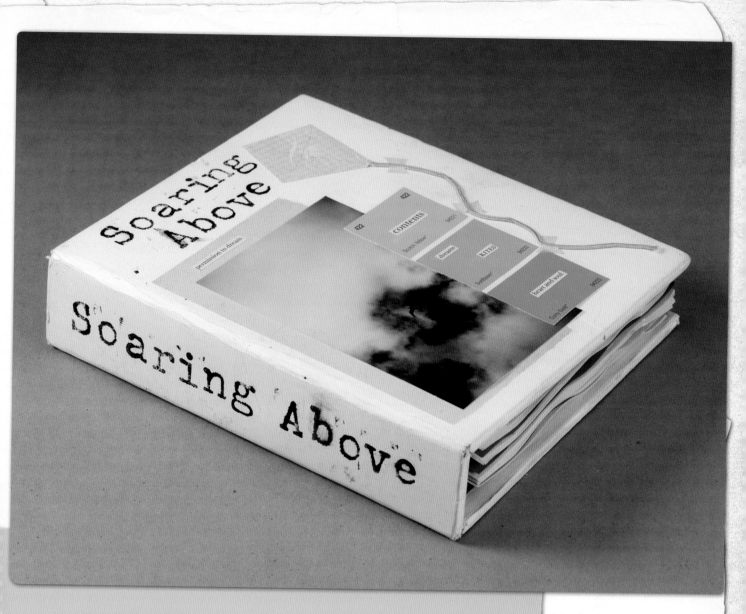

DESIGN EXPLAINED

For this cover I was exploring the theme of
flight using kites as my main image. I cut out
paper in the shape of a kite and used colored
string to make it three-dimensional. I chose
to use a photo of the sky to connect with the
title, "Soaring Above."

embrace the moment

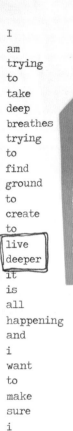

I
am
trying
to
take
deep
breathes
trying
to
find
ground
to
create
to
live
deeper
it
is
all
happening
and
i
want
to
make
sure
i
dont
miss
it

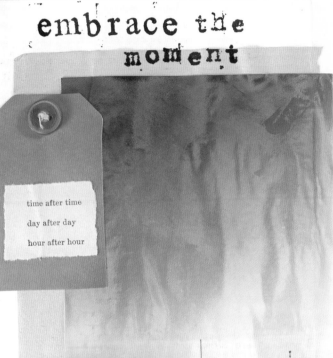

time after time

day after day

hour after hour

E RAILROAD

ST. PAUL · MINNEAPOLIS · WINN

"The WINNIPEGER"

(DIESEL-ELECTRIC POWERED)
For equipment see Table 2

Read Down				Win
① 73 Ex-Sun	Winnipeger 9 Daily	Miles	**TABLE 11** (Central Time)	
	PM			
	8 10	0.0	Lv St. Paul, Minn. ⊂⊃ Ar Union Station	
	8 50	10.9	Lv Minneapolis ⊂⊃ Ar Milwaukee Road Station	

Hold the compass level
row pointing straight ahea
Turn your whole body
the orienting arrow inside
Look up and decide on a
sighting.
Proceed directly to the

Canadian Pacific Station

NO PASSPORTS REQUIRED TO VISIT CANAD

Insofar as citizens of the United States are concerned they may e
Canada, without passports. Regulations do not require passports fo
citizens visiting Canada, although it is desirable that United States
Canada have with them means of identification, such as birth certifica
tion papers, poll tax receipts.

S FOR THIS PAGE

ⓐ Stops to let off passengers from Twin Cities and beyond.
ⓔ Regular stop on week days; Signal stop on Sundays.
▲ Trains 13 and 14 Diesel-Electric powered.
Light face type **AM** and dark face type **PM**
⊂⊃Rail-Auto service available at this point.

Overcoming Obstacles

On a cross-country walk there will probably be occasions when
there is an obstacle in your way—a lake, a swamp, a building, or any
one of a number of things. Well, if you can't walk through or over the
obstacle, you'll have to walk around it.

If you CAN *see across or through your obstacle* it's a comparatively
simple matter: locate a prominent landmark on the other side of the
obstacle, such as a large tree or a building. Walk to it around the ob-
stacle and take your next bearing from there.

Before setting out again, make certain you are on the right track by
taking a "*back-reading*"—looking back toward the point from which
you came. That point should be directly behind you—half a circle
behind you. You could reset your compass for a back-reading by add-

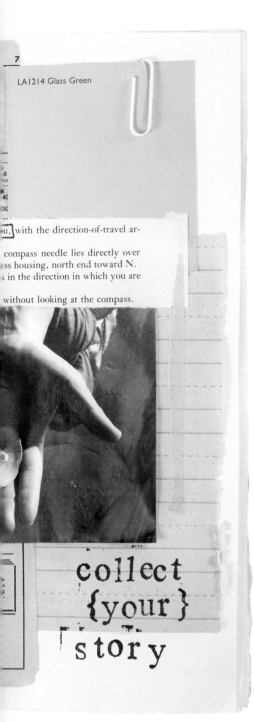

{5} The Inspiration Gallery

Over the last ten years of my art journaling journey I have created over ten books, five that capture my personal journey. The last five years have been filled with adventure and creative unfolding. Here is a collection of images that show you different layouts and how I use the variations we explored together.

These book spreads all begin as basic page layouts and follow through with small but different variations. The majority of the differences come from the book pages or photographs used.

This gallery is here for you to see more options and to provide inspiration, as I always find that seeing other works is helpful to my own. I want you to know you are not alone, and that there is creative freedom in the art journaling process. When looking at these images, make note of the step-by-step processes you learned from this book. Let these images, as well as the steps you have taken, lead you down your own creative path. You, as the artist, will be able to uncover, through your own collage discovery, your own style.

Enjoy the journey along the way.

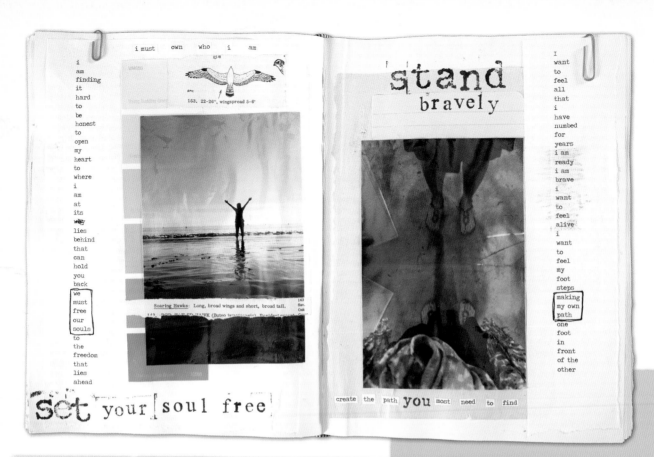

i must own who i am

i am finding it hard to be honest to open my heart to where i am at its lies behind that can hold you back we must free our souls to the freedom that lies ahead

Soaring Hawks: Long, broad wings and short, broad tail.

set your | soul free

stand
bravely

I want to feel all that i have numbed for years i am ready i am brave i want to feel alive i want to feel my foot steps making my own path one foot in front of the other

create the path you most need to find

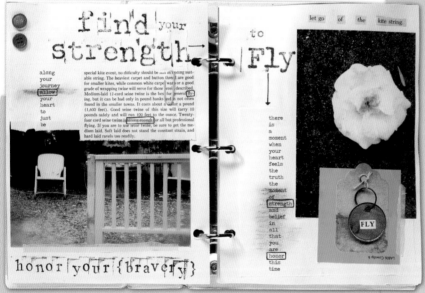

find your strength → to Fly

along your journey allow your heart to just be

let go of the kite string.

there is a moment when your heart feels the truth the moment of strength and belief in all that you are honor this time

FLY

honor your {bravery}

DESIGN EXPLAINED
In this two-page spread I explored the theme of freedom and what that visually looks like. I focused on images of birds flying with open wings and other similar images that conveyed this feeling of freedom. The design elements used in this spread connect both pages through their color. I carried over the blue in the ocean photo (left) and found a photo that had a similar blue in it (right). Then I pulled the green from the scarf over to the left and used the same color paper clip and paint sample.

DESIGN EXPLAINED
In these two pages my main design element is color. I found two images that had both white and yellow in them and used these two colors throughout the pages. I used text and stamped words to tie the two pages togeher. I found a yellow paint sample and added it the right page to bring more yellow onto this page. I used a brown sticker tag on top of it to pull the color from the wood chips in the photo on the left. I also used an oil pastel to add yellow accents throughout both pages.

Visit **CreateMixedMedia.com/art-journal-art-journey** for bonus content.

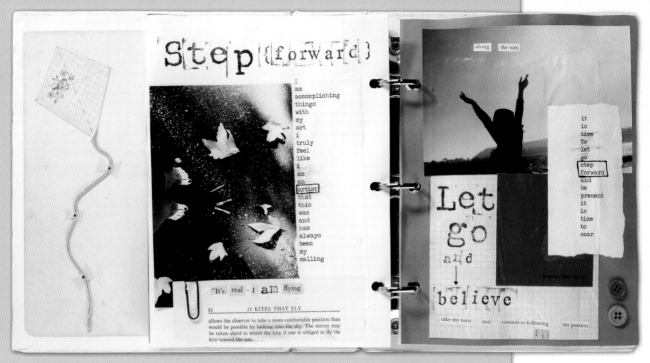

DESIGN EXPLAINED

For these page I used a limited color palette focused on blue and a bit of a burnt orange. I found the photo on the left with the leaves and crayons and wanted to use the blue to tie the two pages together. The image on the left does just that. A blue paint sample and paper clip become accents for the page. The tan background and buttons tie in the brownish colors in the leaves. Linking colors together leads your eye around the page, thereby creating a visual story.

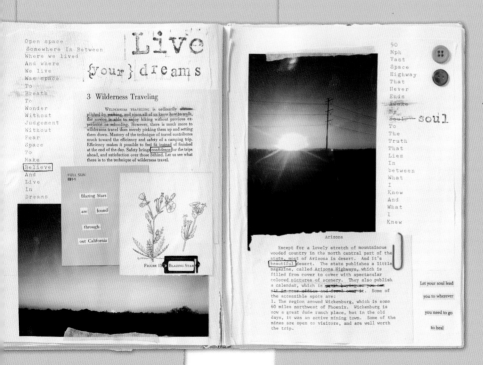

DESIGN EXPLAINED

These journal pages explore the theme of wide open spaces as well as living somewhere new. I had moved to Arizona and wanted to use photographs that documented this part of my life. The sunsets there were beautiful blues, oranges and yellows, and I chose to tie in these three colors throughout the page using two similar photos and pulling the main colors out into "little bits" to add paper clips, buttons and paint samples. The beauty of using colors from photographs is that you often get out of your comfort zone and explore new color combinations you would not normally use as well as notice what colors are created in nature.

Inspirational Words

Adventure
Allow
Allow Things to Unfold
Allow Yourself Time
Along the Way
Anything Is Possible
Armed With Faith
Artist
Balance
Be
Be Bold
Be True
Beautiful
Beautifully
Become
Begin
Beginning
Believe
Boldly
Brave
Bravely Keep Going
Bravery
Breakthrough
Calm
Carry
Carry. . . Love. Laughter.
Change
Choose
Conquer
Create
Create Balance
Create Your Journey
Create Your Life
Dance
Day by Day
Discover
Dream
Embrace
Embrace the Journey
Evolve

Explore
Faith
Fearless
Find
Finding Your Way
Flight
Fly
Follow
Follow Through
Forward
Freedom
Grateful
Grow
Heal
Heart
Home
Honor
Honor the Process
I Am. . .
I Carry. . .
I Need. . .
I Want To. . .
Inspire
Intention
Journey
Keep Going
Leader
Leap
Leap Into the Unknown
Let Go of Fear
Life
Listen to Your Heart
Live
Live Simply
Live With Intention
Live Your Ideas
Live Your Journey
Live Your Vision
Look Forward
Love

Love Who You Are
Miracle
Need
Nurture
One Day at a Time
Opportunities
Passion
Path
Permission
Pioneer
Positive
Possibilities
Process
Progress
Purpose
Rhythm
Season
Seek
Set Positive Intentions
Share
Soar
Soul
Story
Strength
Take Flight
Take the Leap
Thankful
The Joy Is in the Journey
True
Truly
Trust
Truth
Unfold
Unique
Vision
Voice
Want
You Are Enough
You Are. . . Brave.
 Beautiful. Unique.

 Visit **CreateMixedMedia.com/art-journal-art-journey** for bonus content.

Resources

FAVORITE BOOKS

Spilling Open by Sabrina Ward Harrison

Brave on the Rocks by Sabrina Ward Harrison

The True and the Questions by Sabrina Ward Harrison

Messy Thrilling Life by Sabrina Ward Harrison

A Course of Miracles by Helen Schucman

Eat Pray Love by Elizabeth Gilbert

Ten Poems to Change Your Life by Roger Housden

This May Cause Miracles by Gabrielle Bernstein

FAVORITE MUSICIANS

David Gray
Joe Purdy
Angus & Julia Stone
Gregory Alan Isakov
Danna/DeVotchKa
Trevor Hall
Ben Howard
Missy Higgins
Amos Lee
Ray LaMontagne
Jewel
Beth Orton
Brenda Weiler
Chastity Brown
Van Morrison
Alexi Murdoch
Jay Nash
Ford Turrell
Sigur Rós
The Pines

FAVORITE FILMS WITH CREATIVE LEADING ROLES

Crazy-Beautiful
Addicted to Love
Morning Glory
The Giant Mechanical Man
Under the Tuscan Sun
Something's Gotta Give
The Holiday

FAVORITE COFFEE AND TEAS

- Archer Farms Cinnamon Vanilla Nut Ground Coffee
- Yogi Vanilla Spice Perfect Energy Tea
- Celestial Seasonings Sweet Harvest Pumpkin Black Tea
- Folgers Toasted Hazelnut Coffee
- Kivu Coffee Roasters Vanilla Nut

FAVORITE SUPPLIES

Carter's Felt Stamp Pad
Stabilo Point 88 fine 0.4 ink pens
EK Tools fine-point precision scissors

FAVORITE FONT WEBSITES

dafont.com
1001freefonts.com

PHOTO TIPS

- Many retail stores such as Costco allow you to upload your photos online and then pick up the prints in the store.
- Apps are available for your smartphone that allow you to make prints from your photos.
- Use apps like Instagram to add filters to your photos.

STORES

Thrift stores
Dollar stores
Office supply stores
Independent stationery stores

ABOUT THE AUTHOR

I am an honest writer.
A creative mess maker.
I am an artist.
These words hold my heart, my creative journey . . .
My life.

Nichole Rae (Rae is her middle name, something she has stepped into in the last year) has been creating since she was six. Cutting images and words out of magazines and collaging shoeboxes on the living room floor was just the beginning of a creative journey that would unfold over the years. Shoeboxes turned into sketchbooks filled with favorite images, lyrics and poems, which then evolved to her passion for book arts.

In 2004 Nichole had an opportunity to travel from her home state of Minnesota to sunny southern California and take an aspiring artist's two-day workshop retreat about documenting your personal journey through art journaling and mixed-media collage. After this workshop, Nichole created her first mixed-media book on the adventure to California. This creative medium has followed her on adventures to Minneapolis, London and New York, creating books that hold her photos, journals and papers.

AUTHOR PHOTO COURTESY OF
J. Alan Paul Photography

In 2008, she embarked on the beginning of a personal collection of books that documented her days, thoughts and feelings through journaling and photographs. This collection consists of five books (thus far) that hold her adventures living in California, Florida and Arizona. These books, "Finding My Way," "Along the Way," "Somewhere in Between," "Creating My Path," and "Honoring the Process" hold her deepest truth, her strength and bravery. They hold her love, her loss, her thoughts and the journey of self-discovery. These books have traveled with her and are part of the process of stepping into the words Artist Nichole Rae.

A new artistic journey has embraced her days as she carries the excitement of embarking on a new path filled with meeting new people, saying "yes" to opportunities and having her art on display in museums, coffee shops and events.

She is grateful beyond words at age twenty-eight to be following her heart, listening to the voice inside and allowing that voice to guide her, step-by-step, with brav-

ery, trust and love. She has a love for the little moments: finding heart-shaped rocks, collecting leaves, giving hugs, collaging papers and making beautiful creative messes.

Spending most of her days in her studio, at a coffee shop, running along windy paths or embarking on new adventures, she knows that it is in these moments that sweet happenings happen—creativity, connecting, sharing stories, direction—and the whispers of her inner artist unfold, page by page. Nichole Rae is an artist at heart, a truth seeker, a creative mess maker, an honest writer, a collector of life's moments.

She is grateful beyond words for all the people who have supported her along the way, letting her heart's calling soar and be documented in her art. Artist Nichole Rae creates to document her journey, to share her story, to connect with others and to be part of a community that is filled with creative people, beautiful connections and collaborations. She believes we are all on this journey together, navigating our days, creating what we most need to find. Connect with Artist Nichole Rae and share your story at NicholeRaeDesign.com.

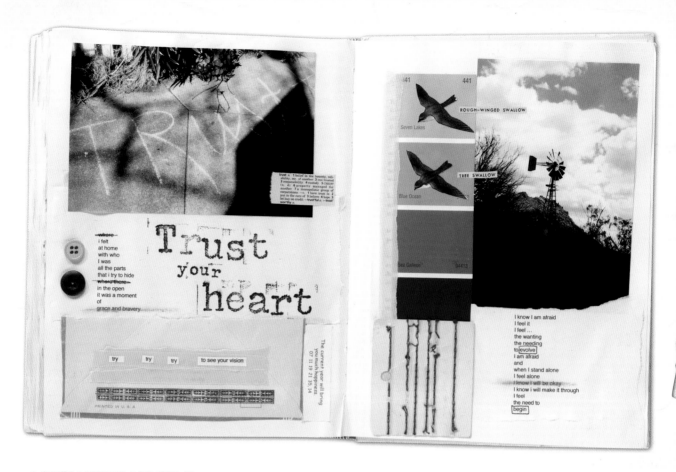

ACKNOWLEDGMENTS

My Gratitude List—The Truest Thank Yous to:

My Mom—For the unconditional love and strength you have given me.

My twin sister, Ashley—For always being there, for your support and inspiring ideas. I love you.

My Dad—For your wisdom and inspiration.

Alan—For all the moments when time stood still and for loving me the way you do.

Jana, "Lady Moon"—For your years of true friendship and the soul connection we share.

Ashley—For your years of true friendship, comfort and support. For the moments enjoying dark chocolate and coffee.

Katy—For your years of true friendship and always being there.

My dog, Dakota—For holding me accountable and for the company in my studio.

Zach—For always believing in me.

Chad—For all your support and for being a brother.

Ashley Nicole—For all the moments of creating, laughing and dancing—Soul Sisters.

Terry Parvan—For seeing something in my art and for opening the door to an opportunity.

Amy Jones—For making a vision come true and for your friendship.

To all who have shown me support and love along my journey, I am grateful for you.

DEDICATION

To the dream chasers, the artists, the truth seekers, the crafters, the risk takers, the makers, to the travelers, to the soul sisters, to the friends, to the path creators, to the honest writers, to the journey takers, to the storytellers, the dreamers, to the ones who carry love, bravery, courage and faith along the way.

This book is dedicated to you.

Index

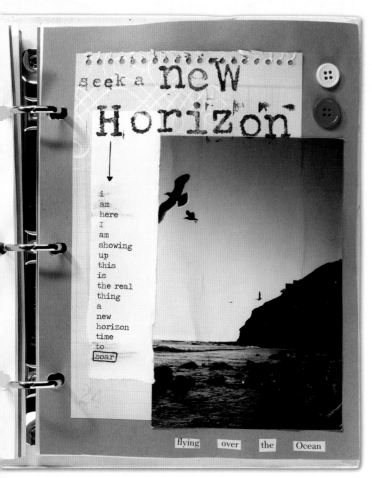

 Other fine North Light Books are available from your favorite bookstore, art supply store or online supplier. Visit our website at fwmedia.com.

18 17 16 15 14 5 4 3 2 1

DISTRIBUTED IN CANADA BY FRASER DIRECT
100 Armstrong Avenue
Georgetown, ON, Canada L7G 5S4
Tel: (905) 877-4411

DISTRIBUTED IN THE U.K. AND EUROPE
BY F&W MEDIA INTERNATIONAL LTD
Brunel House, Forde Close, Newton Abbot, TQ12 4PU, UK
Tel: (+44) 1626 323200,
Fax: (+44) 1626 323319
E-mail: enquiries@fwmedia.com

DISTRIBUTED IN AUSTRALIA BY CAPRICORN LINK
P.O. Box 704, S. Windsor NSW, 2756 Australia
Tel: (02)4560 1600
Fax: (02)4577 5288
E-mail: books@capricornlink.com.au

ISBN-13: 978-1-4403-3007-0

Edited by Amy Jones
Cover design by Amanda Kleiman
Interior design by Wendy Dunning
Photography by Christine Polomsky and Kris Kandler
Production coordinated by Jennifer Bass

METRIC CONVERSION CHART

To convert	to	multiply by
Inches	Centimeters	2.54
Centimeters	Inches	0.4
Feet	Centimeters	30.5
Centimeters	Feet	0.03
Yards	Meters	0.9
Meters	Yards	1.1

Ideas. Instruction. Inspiration.

Receive FREE downloadable bonus materials when you sign up for our free newsletter at CreateMixedMedia.com.

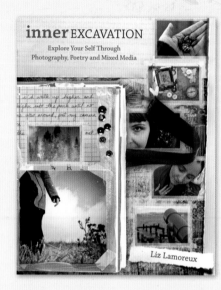

Find the latest issues of *Cloth Paper Scissors* on newsstands, or visit shop.clothpaperscissors.com.

These and other fine North Light products are available at your favorite art and craft retailer, bookstore or online supplier. Visit our websites at CreateMixedMedia.com and NorthLightShop.com.

 Follow Create Mixed Media for the latest news, free wallpapers, free demos and chances to win FREE BOOKS!

Visit artistsnetwork.com and get Jen's North Light Picks!

Get free step-by-step demonstrations along with reviews of the latest books, videos and downloads from Jennifer Lepore, Senior Editor and Online Education Manager at North Light Books.

Get involved

Learn from the experts. Join the conversation on *Wet Canvas*